Sketching Landscapes
in Pen and Pencil

Sketching Landscapes in Pen and Pencil

Joyce Percival

Guild of Master Craftsman Publications

First published 2004 by
Guild of Master Craftsman Publications Ltd,
166 High Street, Lewes,
East Sussex BN7 1XU

ISBN 1 86108 336 X
A catalogue record of this book is available from the British Library.

Publisher: Paul Richardson
Art Director: Ian Smith
Production Manager: Stuart Poole
Managing Editor: Gerrie Purcell
Commissioning Editor: April McCroskie
Editor: James Evans

Cover and book design: Lloyd Raworth
Typeface: Rotis and EverlysHand

Studio photography: Anthony Bailey
Cover photograph: Paul Richardson

Colour origination: Icon Reproduction, London
Printed and bound: Kyodo Printing, Singapore

A special thank you to Rod and Sue Williams,
for happy sketching holidays
in Pembrokeshire

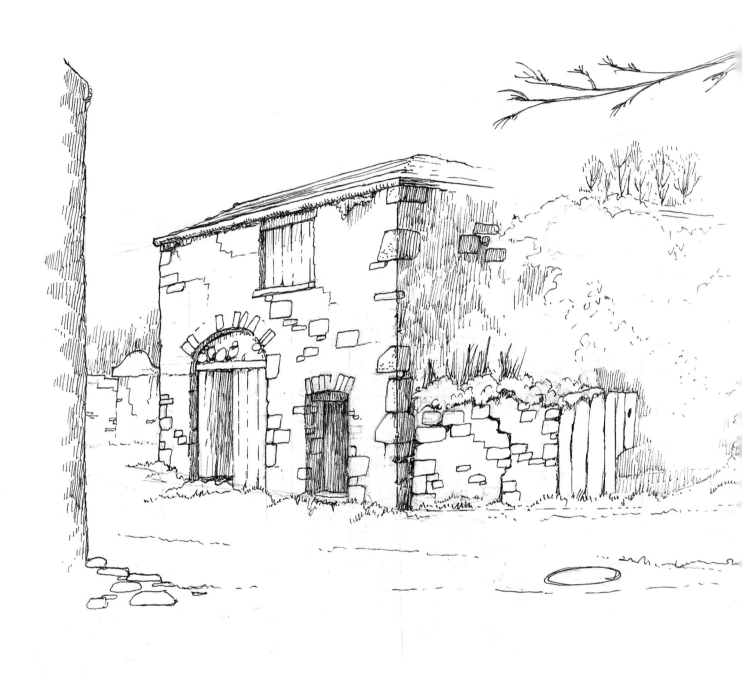

Contents

Introduction

We are going to look at the landscape, with its varying aspects of the rural and urban scene, and then explore the possibilities of drawing it with pens and pencils. The aims of this book are to interest both beginners who have discovered that they like drawing and need to know more about its basic requirements for a measure of success, and those who want to expand their present capabilities in order to increase their enjoyment of drawing.

I have described some problems you are likely to meet and how you can deal with them, and I have illustrated this by creating some basic line diagrams and various sketches, both simple and more detailed. The techniques shown in the sketches can be used to depict your own surroundings.

The book is arranged so that you can select the part which is of particular interest to you at any one time. However, most of the sections interact with one another, so that points illustrated in one will probably apply to others as well, especially those described in chapters 1–6, which cover some of the basic techniques employed in sketching.

I have written about and drawn the subjects that I have most enjoyed myself, and although I am interested in people and what they do to have an impact on our lives and surroundings, I find that in themselves they are very complex subjects for an artist to consider. I have, however, chosen to

include small and simplified figures if they are needed to give scale in a composition. Animals, both wild and domesticated, also need careful study, but in middle and far distances their forms can be reduced to simple shapes (see page 21).

Observation, appreciation and delineation

The main purposes of this book can be summed up in three words: observation, appreciation and delineation. Observation means looking carefully at all aspects of your subjects, appreciation means an understanding of its contribution to your surroundings, and delineation means drawing the image suggested to you by the scene. I use the word 'suggested' because, often, a little imagination can creep in to alter the actual scene, and then personal interpretation comes into play.

There are many different ways in which to use pens and pencils, and different artists exploit the characteristics of these materials in various ways.

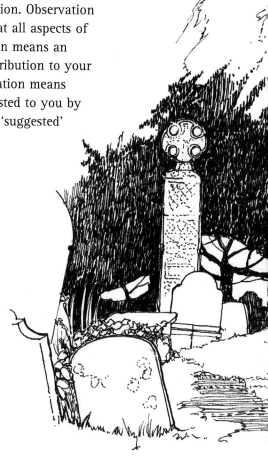

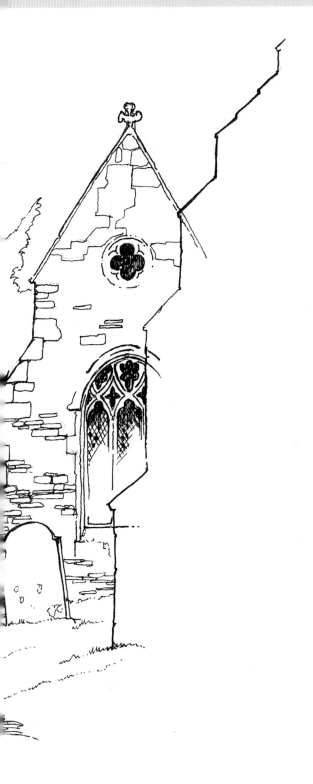

The way I draw is simply the way I like to do so; you will eventually develop your own individual way of depicting the subjects around you. In this book, I have merely tried to give you some guidance on how to tackle some common problems.

Always look carefully, however briefly, at your subject to see what attracted you to it in the first place; then you will be able to use your understanding of line, composition, perspective, shadows and tone to translate your feelings on to paper. For anyone new to sketching, and for those requiring a 'refresher', these techniques will be covered in detail in chapter 4, *Understanding basics* (see page 38).

It is necessary to consider practicalities in order to enjoy yourself fully. By this, I mean consider where and how you are going to sit in comfort – on the grass (which might be damp) or on a wall (which might be hard and uneven), or in the sun or shade. Look for available shelter in case of a sudden downpour, wear suitable clothing to combat heat or cold, and carry a vacuum flask or bottle of water and sufficient food to last throughout the day.

Most importantly of all, you should enjoy what you set out to do, even if the result is not quite what you would wish! I find that being in a chosen area and taking note of what I see and feel around me is what I like to do.

Using a sketchbook

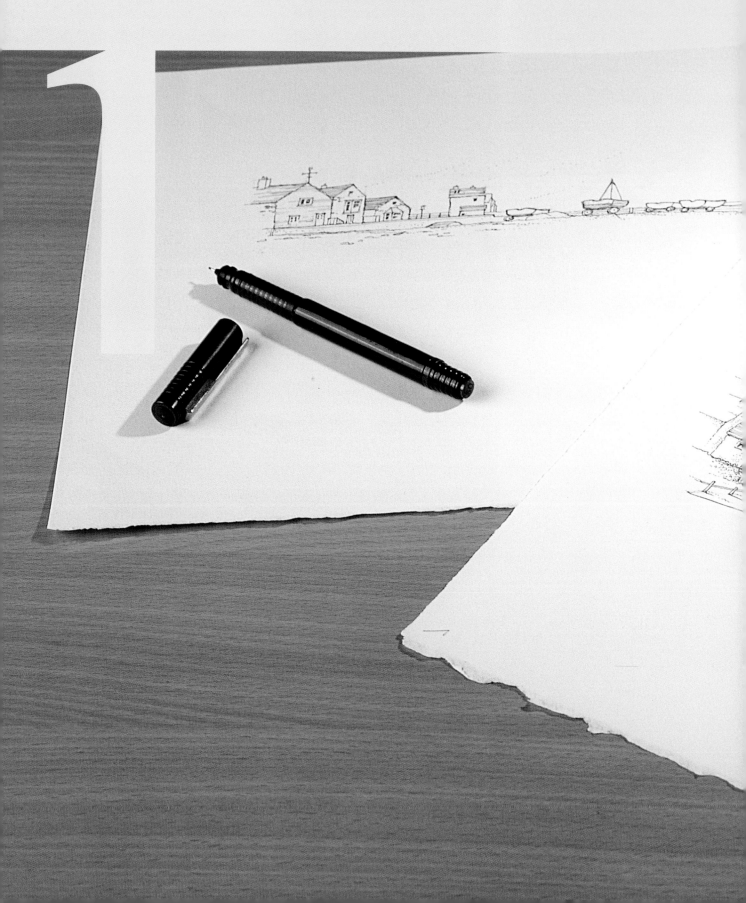

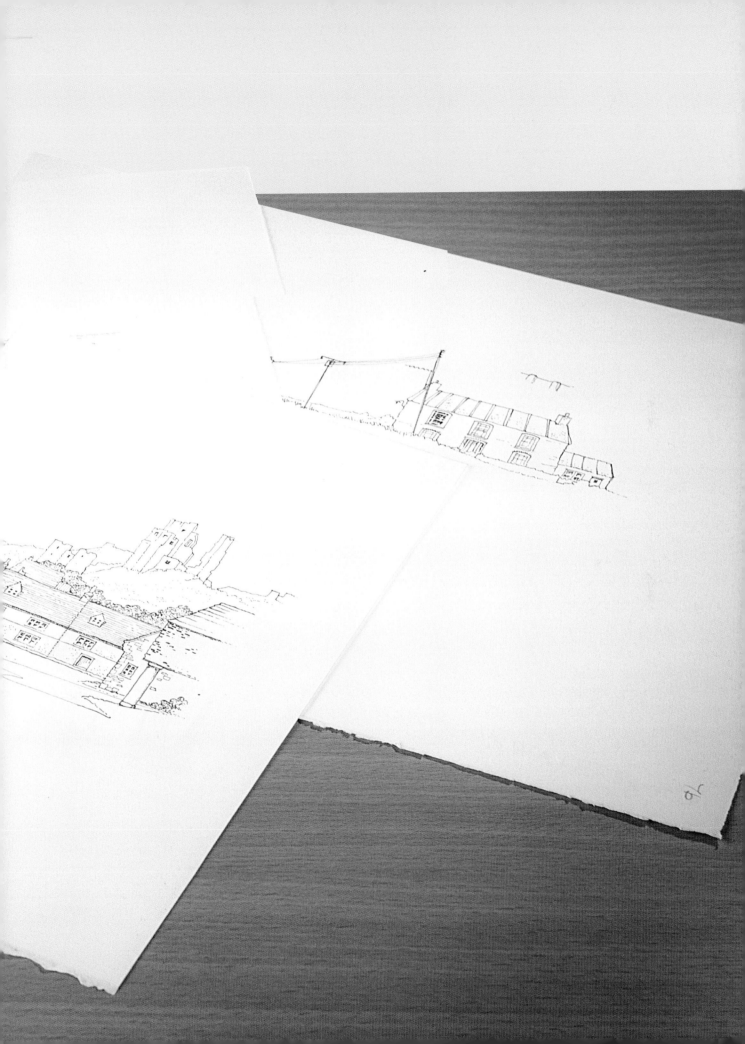

1 Using a sketchbook

People often ask for a definition of a sketch, and how it differs from a drawing. It could depend on factors such as the amount of time that you have available or on the degree of finish related to what you set out to accomplish. A quick sketch, perhaps with colour notes, is often made to form the basis of a finished piece – perhaps a watercolour, oil or pastel picture – to be made later on, or a more detailed drawing made on site can be delightful in itself.

You might go somewhere new having gained an idea of the scenes that you would like to sketch from books or television. However, it is best to go with an open mind and be receptive of what you might find. Weather conditions can alter a scene quite dramatically from what you had visualized, sometimes giving an interesting new slant to a subject. This also applies to places you already know, because different weather conditions, seasons and times of day can give entirely new impressions.

Viewfinders

When you are considering what you would actually like to draw, it can be useful to isolate parts of the scene in front of you so that you can select those that emphasize that first reaction to it. These could come from the composition of the scene (i.e. the arrangement of its components), its perspective (which depends on your viewpoint), its tone (which shows its contrast), or its shadows (which are produced by the direction and intensity of the light). This observation will come readily with experience, but if you are a beginner it will help if you make some viewfinders.

In explaining how to make a viewfinder, I will assume that you will be using an A4-size sketchbook, although the principle will apply to any size or proportion. If you cut a rectangular hole about 3x2in (75x50mm) in a piece of card large enough to create a thick border, this will be in the proportion of one page of your sketchbook. If you make another viewfinder with a hole about $3^3/_4$x2in (95x50mm), your sketch will go over into a quarter of the opposite page. If you make a third viewfinder with a hole about $4^1/_2$x2in (115x50mm), it will take up one half of the opposite page.

To help you with your composition, it will be useful if you make some viewfinders in advance to take with you on any of your sketching expeditions. A viewfinder is merely a piece of card with a hole cut in it.

Drawing complex scenes

If a scene is quite complicated, do not try to sketch everything: be selective. There are both practical and compositional reasons for this. First, the images of your scene could be too small and lack impact. Second, any notes you make on your sketch will add confusion. If you do want to include most of what you see, use two opposite pages in your sketchbook, going right across the middle. This is particularly useful when your view has a pronounced horizontal emphasis.

Above: Sketching with pen and pencil does not involve the use of a lot of equipment, so you can still enjoy it if you need to use public transport.

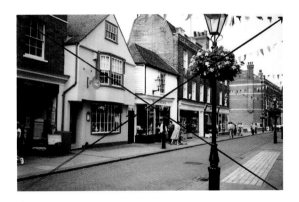

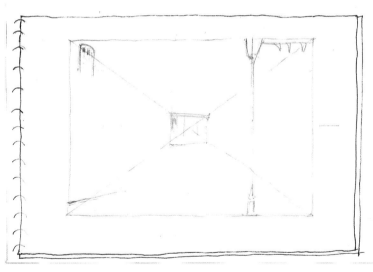

Use your viewfinder to assess the area that you want to sketch. While holding it, lightly pencil a rectangle of the correct proportions into your sketchbook, and faintly sketch the diagonals. Look through your viewfinder again and mark the centre of your view with a little sketch. This may be the focal point of your proposed picture, or it may just be a part of the actual scene.

Still holding your viewfinder, roughly sketch a small part of each of the four corners of your view (in this example, sketch in the position of the lamp-post, which is about

one-quarter of the distance from the right-hand side). Now concentrate on sketching the remaining parts of your picture to join up with the corner and centre parts, bearing in mind that you might find that you need to make adjustments to the size of these earlier marks.

When you hold any of these viewfinders at varying distances from your eye, you will see more or less of the view in front of you, as required. This will enable you to select the view you prefer and see how much room it will take up on your sketchbook page or pages. However, you will still need to make sure that you draw the image so that it fits on to your page or pages.

If you usually draw on one page of your sketchbook, do not feel that you have to fill the entire page by drawing right up to the edges. You might like to be aware of a technique called 'vignetting' which I describe in the section on composition (see page 40). You could also enclose part of your sketch with a couple of lines to show the extent of the sky (if any), and let the rest flow into blank paper. You will see that I have done this in many of my illustrations.

A selection of extracts from my own sketchbooks are shown throughout this book, together with drawings based on sketchbook information. Those taken from or based on sketchbook examples include the sort of notes you should make for future reference. You should always include the season of the year and time of day, and weather notes can be helpful as well.

Choosing pencil or ink

When beginners start to make a sketch they are often intimidated by the thought of the permanence of ink lines. They believe that pencil is more flexible, because marks can be easily erased. While with pencil this may be the case, the actual process of rubbing out can interrupt your directions of observation and thought, and the softer grades of pencil used for sketching can smudge easily if erasing is not done very carefully. The result is not what you would wish to see!

A pen or pencil line drawn in slightly the wrong position does not really matter in a sketch. Drawing more lines over or alongside can show the way your thoughts are altering as you continue. Sometimes, leaving your lines of alteration can add character to your sketch. Some established artists have done this and so left us with indications of their thought processes. This is not an excuse for careless drawing; it is just an encouragement to progress as you go.

The decision to use pen or pencil should be considered in relation to the specific subject, and this point is covered in the chapter on *Subjects and styles* (see page 18).

Choosing subjects

You might choose to have two or three sketchbooks and use each of them for a different subject or theme. One of them could be devoted to making a record of a holiday, in which you could include the everyday

'Inking in'

A trap some sketchers fall into is that of producing a careful pencil drawing and then going over the lines with a pen, which does not do justice to the properties of either pen or pencil. This act of just 'inking in' often destroys any creative thought processes, but it is often necessary to sketch some important points lightly in pencil (and perhaps add a few helpful lines such as perspective indications) before using pen and ink.

things, such as shops and cafes, the house, cottage or hotel where you stayed and its surroundings. Trips out into the countryside could add further interest to sketching.

If you stayed by the sea, you could draw shells left on the beach, boats in the harbour, fishing tackle, and so on. You might add notes made from visits to local museums,

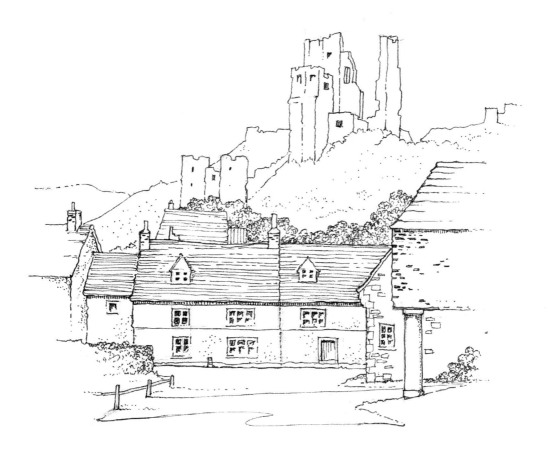

Above: This is an example of a form of partial vignetting (see page 47), where the lower part of the picture forms the main interest against the simplified treatment of the castle in the background. What is important here is the way in which the lines of the buildings in the lower part of the picture gradually merge with the surrounding white paper. Details of the roofs, walls and foliage also diminish.

libraries and visitors' centres and include reference photos and postcards on a few of your pages.

You do not even have to be away from home to make any record; you might live in a city, village or the suburbs and could make sketches to record changes over a period of time – perhaps a year – noting the effects of the changing seasons. With all of these, you can add a touch of colour with coloured inks, pencils or watercolour.

If you use your sketchbook in your own home, you might like to set up a simple arrangement of articles in your home or garden surroundings; you may enjoy drawing these items that you have especially selected and will remember their associations with particular events.

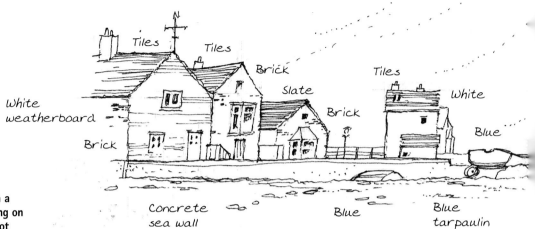

Right: I sketched this little scene on a cool, sunny summer's morning, sitting on the beach with a vacuum flask of hot coffee at my side.

Right: I liked the way that the telephone posts and wires linked the houses together in this scene. From where I was sitting on this warm, sunny morning in summer, the long, dry grass in front of me sloped up to the houses at the top.

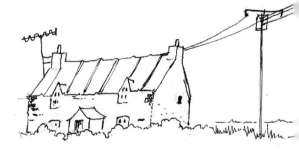

Roughly coursed natural local stone

Enlarged detail of windows

Brick is warm and red, so are
tiles. Boats are fibreglass

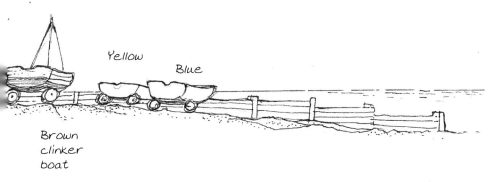

Yellow

Blue

Brown
clinker
boat

Roof rolls –
slurried over light
greenish fawn

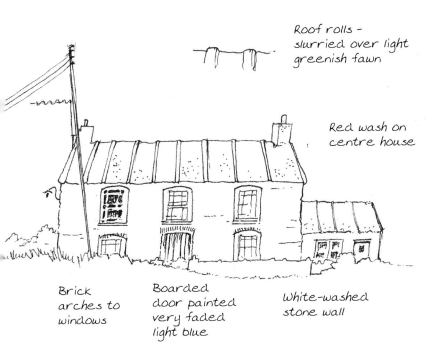

Red wash on
centre house

Brick
arches to
windows

Boarded
door painted
very faded
light blue

White-washed
stone wall

Subjects and styles

2 Subjects and styles

Pen and ink drawings are crisp and firm. According to the types of pens used, they can be quite delicate in appearance, or robust with good contrasts in tone. The firmness of line is particularly suited to depicting buildings and other structures, industrial or rural machinery and any subject where the main attractions lie in lines, shapes and textures. These can include natural subjects like rocks, cliffs and trees.

Choosing the right medium

The selected use of different grades of pencils will be suitable for sketching the above-mentioned subjects, and pencils are also able to give soft gradations of tone. They are particularly effective when your main subjects include interesting cloud formations or distant scenery, and when they have misty backgrounds.

In the chapter on *Materials* (see page 30), I mention that some types of pens have water-soluble inks that give soft effects in parts of a drawing, and water-soluble graphite pencils give a similar appearance. Sometimes it can be effective to combine pen and pencil work in the same drawing.

When you are first attracted to a scene, consider whether this attraction can be expressed in a sketch made with pens or pencils on their own. If you were initially attracted to something where the main interest was in a splash of colour, you can always add this to your sketch by using fibre-tip pens or coloured pencils, or by just making colour notes. I enlarge on this aspect in the chapter on *Colour* (see page 64).

Detailed images made with pens and pencils usually result in quite small drawings, where the viewer can explore the whole with one look, while appreciating the details. Together with framed pictures, these small drawings are particularly suitable for book and magazine illustrations, greetings cards and similar uses.

There might be times when your subject suggests a broad treatment, and you might, at any time, like to use a free approach, with broad outlines and large filled areas. You will need a large sketchbook (A3 or larger) to depict these sweeping interpretations. You can use coloured ink markers, broad fibre-tipped pens and brush-tipped pens to achieve different effects. If you are using pencil, choose a grade capable of producing deep darks, in the range of 3B to 6B. Sharpen it to a long point and use the side (with varying pressure in order to fill areas with broad, graded strokes) or trim to a chisel edge.

Developing your own style

Your individual style will develop along with technique, but the purpose of your sketch might influence the style in which it is made.

People and animals can be reduced to simple forms when you wish to use them in your pictures to give scale and some further interest. Here, I have given an indication of how to draw them in this way.

Left: These images of people would be suitable for placing beyond the middle distance in a sketch. I have sketched the back views, and have joined the oval of the head to the shoulders in some cases to represent long hair.

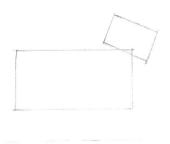

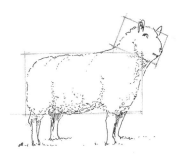

Left and below: These sketches of a female sheep and a cow show how their outlines fit into geometric shapes. Some sheep have long-haired fleeces and some have short, curly hair: this makes their outlines different. The ones I have drawn here have short hair.

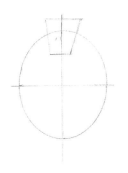

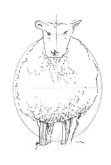

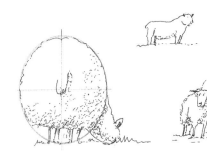

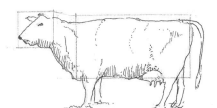

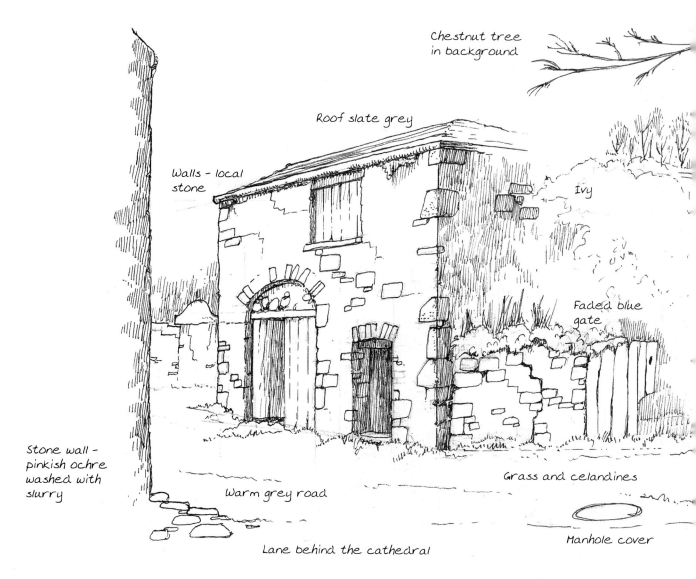

Chestnut tree
in background

Roof slate grey

Walls - local
stone

Ivy

Faded blue
gate

Stone wall -
pinkish ochre
washed with
slurry

Warm grey road

Grass and celandines

Lane behind the cathedral

Manhole cover

Woodwork on house is dark,
purplish-brown

Above: I was interested in the tumbledown state of this little building and the textures and shapes of its stones and woodwork amid the surrounding foliage. The bright sunshine emphasized these as well as the colours, which were an added attraction. I hoped to show this interest in my sketch and so reflect my feelings.

A few days later, I went back to take a photo, just to record some information about the tones of the background for future use. It was a dull day and all of the tones were subdued. The textures of the stones and woodwork and the recessions of the openings had lost their emphasis, so I was pleased that I had sketched the scene earlier.

Trees in background

Lichen-covered stones

For example, should a sketch be drawn in simple black and white, or should a varient such as sepia or grey be used? Alternatively, should it have additional colours? Should a sketch be traditional in concept or more design orientated, perhaps with the emphasis on shapes?

These ideas can be considered when you are in front of your chosen subject with your sketchbook. The actual scene before you might spark off ideas for the style in which the sketch might develop later.

However, when making sketches at your leisure – as opposed to investigating a possible commission – you can either make a selection of the part which you want as a final image, or record as much detail as possible. In the latter case, you can take notes so that you can develop it later in any way you choose, or you might prefer to leave what you have drawn, making it a record of a pleasant time.

'Graphic' images

The term 'graphic' is often applied to images where the qualities of the art materials used, such as those producing line and colour, are emphasized. Details of some subjects, such as tree bark and reflections, sometimes show design qualities that can be treated in a graphic manner. Although pens and pencils are, in themselves, instruments that produce graphic-type images, most of the drawings in this book have a representational quality. However, some examples of graphic images are shown on the following pages, and these sketches also give an indication of the variety of subjects available and the different styles that can be employed.

Above: An impression of a blossom-laden May tree in a clearing in a wooded Welsh valley. (May is a common name for the hawthorn or *Crataegus monogyna*.)

I have used an HB pencil for the background of trees and foliage. I feel that black pen and ink would have overpowered the blossom itself. My friend was sitting some way in front of the tree sketching a distant view behind me so I put her in to give some scale.

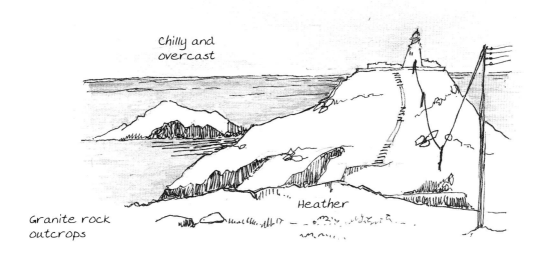

Chilly and
overcast

Heather

Granite rock
outcrops

Above: I wanted to record this scene as a pleasant
reminder of a sketching outing, despite the weather
which was chilly and overcast although it was summer.
The tonal values were very similar, so to give interest to
the sketch I put in a pencilled tone over the sea and sky
to emphasize the lighthouse and headland.

Below: The lighting was rather flat, but
this industrial harbour scene appealed
to me because of the colour of the
distant buildings and the shapes in the
foreground. I applied the colour with
brush pens.

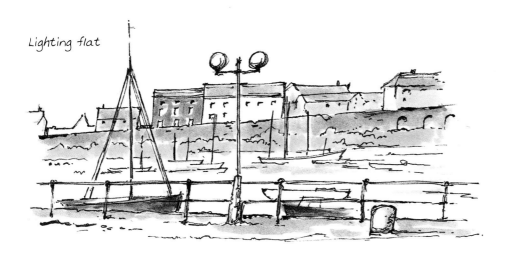

Lighting flat

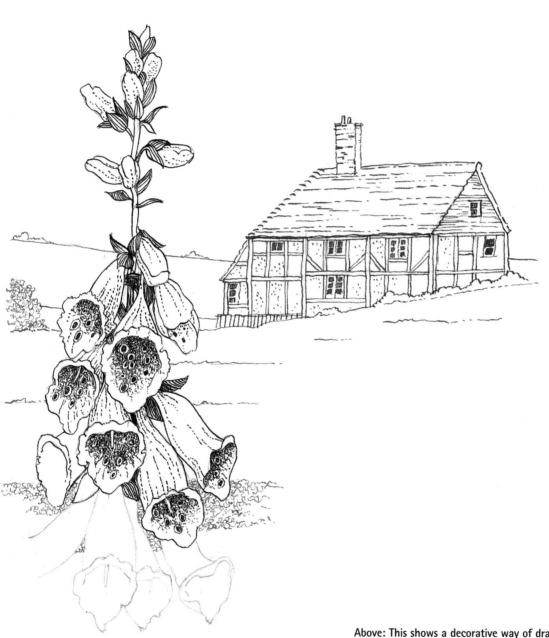

Above: This shows a decorative way of drawing plants, in this instance a foxglove. I have drawn the plant against a background of a small cottage, and used a lighter colour for this and the background so as to emphasize the form and pattern of the plant itself. The L-shaped composition makes it suitable for using in conjunction with lettering for a greetings card or leaflet. I drew this image using a pen with a fine, flexible nib, but left a pencil outline for some of the flowers, showing you how to begin, before inking the outlines and adding the pattern inside the foxglove 'fingers'.

Sketching Landscapes in Pen and Pencil

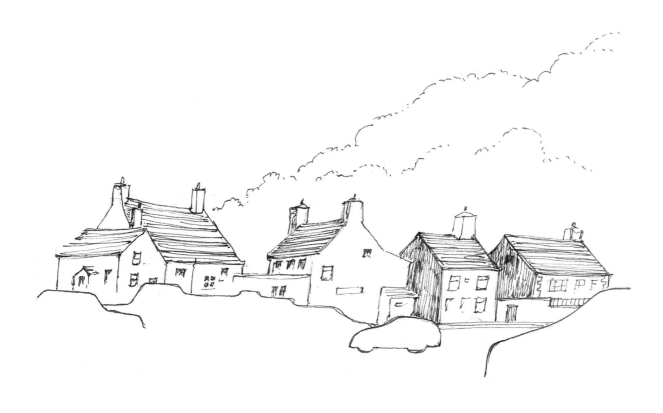

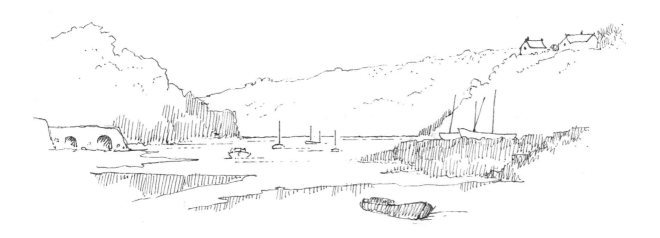

Above: I made these sketches on a warm sunny autumn afternoon just as a reminder of a very pleasant day. I had no definite plans for using them in any future paintings, but simply enjoyed doing them.

The houses are at the top of a narrow inlet from the sea, which is sheltered by rising ground to form a harbour. It was used in the past to take boats carrying lime to use on the acid soils of the region, and this was produced by burning in the lime kilns that are shown on the left of the bottom sketch.

I sat sketching the houses first: the car park obscured a lot of them so I used the outline of the cars to form the basis of the sketch. They formed part of the memory of the day, so that is why I chose to record their presence. The walls of the houses have been given a white finish and the roofs are a grey colour.

When I had finished here, I turned around and sketched the outlet towards the distant sea. The boats on the higher ground had been towed there up the sloping road leading from the town behind the houses.

Above: A scene drawn in outline, with part of it emphasized in a decorative way, by including detail and adding colour.

Right: Based on some photographs showing quarrymen's old houses situated by the stone quarry. Pen and watercolour.

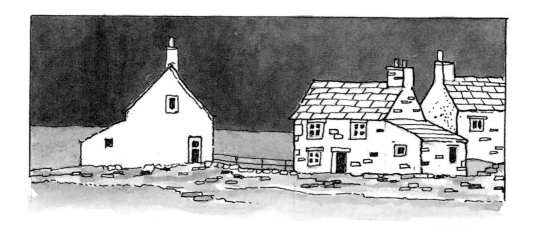

Sketching Landscapes in Pen and Pencil

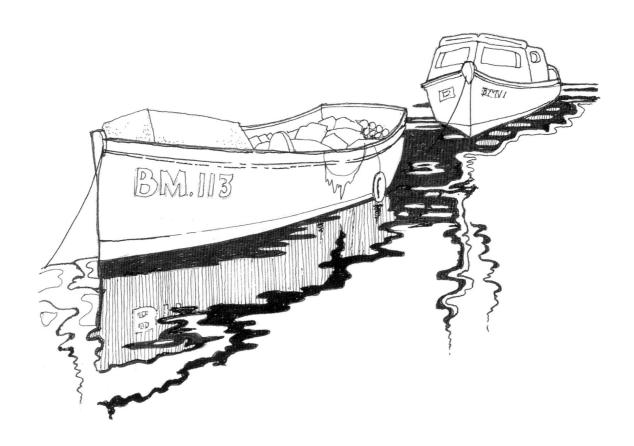

Above: A decorative treatment of reflections in water

Above and right: Two little sketches, one in pencil (above) and one in pen and ink (right), idly drawn from my imagination on scrap paper while waiting for a phone call.

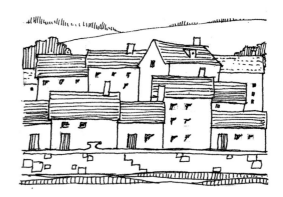

Materials

3

3 Materials

Broadly speaking, you can draw with any type of pen or pencil and on any paper surface. However, this is a sweeping statement that needs to be explored further in order to be of any practical use. In particular, it is helpful to always carry a small (possibly A5) sketchbook filled with good-quality cartridge paper, and a pencil (possibly B grade), so that you can make a quick sketch and jot down notes on anything that might come your way unexpectedly.

The manner in which different types of pens and pencils act on different types of paper results in various ways of showing a subject. In the following pages, I have described some of the different materials that are readily available.

Pens

Many different types of pens are available, and choosing the one that best suits the

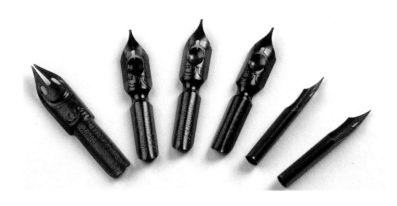

Above: A selection of nibs of the type used for dip pens. Nibs are available in numerous widths, and ink can be applied to the page with varying amounts of pressure to produce further variations in line thickness.

Below: Technical pens such as these were developed primarily for technical drawing, but also make excellent pens for freehand sketches. Some of the sketches featured in this book were made using technical pens with nibs of 0.25 and 0.18mm, which are ideal for detailed work.

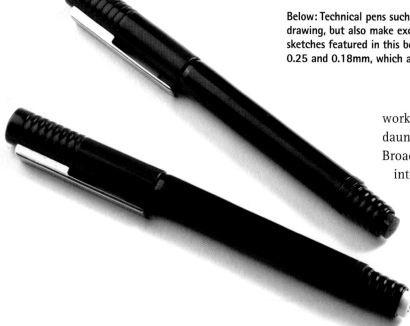

work you wish to do can be a rather daunting, although enjoyable, experience. Broadly speaking, pens and their nibs fall into four categories:

Technical pens These have changeable nib assemblies that give firm and unvarying lines. They are used in technical-drawing offices and

by graphic designers, as well as for freehand sketching and drawing. Pens are made with nib sizes up to 0.7mm, but I like to make small sketches in my A4 sketchbook and so use 0.25mm and 0.18mm for this fine work.

Art fountain pens These are available with various nib widths and are fitted with replaceable cartridges or can be 'squeeze-filled' from a bottle of water-soluble ink. Art pens have the advantage of some flexibility in the nibs – a feature that can be used to produce lines of varying thickness.

Artists' fibre-tip pens These are widely used now. The tips are available in various thicknesses and these tend to vary with the maker of the pen. Each tip produces a line of non-varying thickness, but as the integral ink supply starts to run out, the line becomes 'scratchy'. They are highly portable and inexpensive (compared with technical and fountain pens), so it is easy to carry a replacement with you. I have found two or three makes in which the 'fine' tip suits my style of drawing and I have used these in some of the sketches that appear in this book. If you choose to try a fibre-tip pen, you will need to check whether it is water-resistant or water-soluble. (I find that it is good practice to test any water-resistant pen by doing some practice lines and 'squiggles' on a spare piece of paper; let them dry and then apply water to them.) Pens with water-soluble ink can give attractive soft effects to your lines with the careful addition of water. It is a matter of knowing the effect you wish to produce.

Dip pens A dip pen consists of a wooden or plastic holder into which a nib is fitted. The nibs are usually bought on a card in various sizes. They are flexible and this feature can produce interesting varied lines according to the pressure you apply. The main drawback to dip pens for outdoor sketching is the need to take a bottle of ink along with you, as this can easily be knocked over.

Inks

Inks are described as waterproof or non-waterproof, depending on the substance used for their bases. Waterproof inks (other than acrylics) are based on shellac. This tends to clog up easily and so they are not generally

Bottles of water-soluable ink such as these are used with art fountain pens, dip pens, and also some types of technical pen. However, of these, only dip pens require the use of an ink bottle while sketching on site outdoors.

Fibre-tips

Flexible nib　　Fine　　Medium　　Thick　　Very thick

Technical pens

Fine　　Medium　　Thick　　Brush pen (no water)　　Brush pen (added water)

Water-soluble medium graphite

Pencils

HB　　B　　2B　　3B　　a. no water　　b. water added

Used on their sides

The effects produced by using various pens and pencils.

Used for cross-hatching

used in fountain pens. Indian ink is waterproof, and this can be used safely with dip pens.

Brush pens and coloured fibre-tip pens are convenient for adding colour to your sketches when you are away from home. Brush pens have a flexible brush-like tip, and usually have a fine tip at the other end. Coloured fibre-tip pens vary a lot in quality; those sold in specialist art shops and by mail order have a good range of colours. Both brush pens and coloured fibre-tips are obtainable in various widths and are useful for making quick colour notes and filling in areas, but their colourfastness cannot be guaranteed. Both types of pen may be either water- or spirit-based. Some of the spirit-based ones, which are usually called 'markers', bleed through to the back of the paper and could spoil a sketch on the previous page of your book, so you would need to buy one or two to test them.

Pencils

These can be obtained in various degrees of hardness or softness, described by the letters 'H' or 'B'. Broadly speaking, degrees of H are hard and degrees of B are soft. The medium degree of HB varies very much in its manufacture. Cheaper pencils are widely used for the everyday making of lists or writing notes, but those of artist's quality are capable of a good range of tones according to the way in which they are used. (See the diagram, left, for examples of the range of H and B pencil tones.)

The most popular degrees of pencil hardness used by artists to draw in an A4 sketchbook are HB, B, 2B and 3B. These are capable of producing both fine and broad lines, which vary in tone according to pressure. Pencils can be sharpened to a fine point for detailed work and cross-hatching, or a 'chisel' edge to

Pencils range in their level of hardness, generally from 9H (the hardest) to 9B (the softest), and this affects both the thickness of the line and the depth of tone produced. A selection covering a range of around HB to 3B should be sufficient to produce the variety of tones and line thicknesses required for sketching.

produce broad sweeping lines in quick sketches. For large sketches, probably those made in an A3 book, pencils with a larger lead, such as those in 6B pencils, can be sharpened to produce a wide chisel edge that is highly effective.

Water-soluble graphite pencils are obtainable in degrees of softness and can produce misty and other soft-edge effects when a little water is added to the lines and areas where they have been used.

Paper

Paper used to be sold in traditional sizes of imperial measurements. Most of these are still available alongside those produced with metric dimensions, the 'A' series. Both measurements are not directly comparable, but the table below gives the sizes.

Paper comes in many types and surfaces. The surface for general sketching with pens or pencils should be smooth, so that clear, clean lines can be made. Artist's quality cartridge paper is very suitable for this and can be obtained in ordinary and heavy weights. Hot-pressed paper (HP) also has a smooth surface and the degree of smoothness can vary according to the manufacturer; you will need to try out a few samples to find the one that suits you. The weight of a paper is expressed in grams per square metre (gsm) or pounds per ream (lbs).

You will also come across the 'Not' surface. This means that it has not been treated with hot rollers (as is the case with HP). The 'Not'

Common paper sizes

The following table shows the most commonly found paper sizes, and lists their dimensions in both imperial and metric standards. The first four paper types are based on the imperial system, which is still the main standard used in the US. The second set of four paper sizes is based on the metric 'A' standard. The largest size (A0) measures one square meter and the height/width ratio remains constant for all sizes, which in effect means that you get the A1 size by folding an A0 paper in two, and so on.

Name	Size	
	(Imperial)	(Metric)
Imperial	30x22in	761x559mm
Half-imperial	22x15in	559x381mm
Quarter-imperial	15x11in	381x279mm
Eighth-imperial	11x7½in	279x190mm
A1	33x23⅜in	840x594mm
A2	23⅜x16½in	594x420mm
A3	16½x11¾in	420x297mm
A4	11¾x8¼in	297x210mm

A selection of different spiral-bound sketchbooks, showing the variations available in terms of paper size, texture and colour. It is important to determine in advance the type of sketches you feel you are most likely to make and then choose the right type sketchbook accordingly, although it can be useful to take some loose sheets of an alternative type of paper to cover different eventualities.

surface (sometimes called cold-pressed or CP) is very popular with watercolour painters because it is available in many textures. Some watercolourists like the smoothness of hot-pressed paper if they are painting very detailed subjects. The surface known as 'Rough' is quite highly textured and is also used for large watercolour paintings.

For sketching out of doors, I like to use a spiral-bound A4 book with cartridge paper. I usually take some small sheets cut from hot-pressed paper as well, which I can attach to my sketchbook if I so wish. I might want to add some watercolour to my sketch and the heavier weights of HP paper might be more suitable for this.

Understanding basics

4 Understanding basics

Because a subject appears to be beautiful or exciting, this does not mean that you will automatically produce a beautiful or exciting picture within the confines of your sketchbook. You will need to think about what has appealed to you and why this was so. You will also find it helpful to know some of the basic facts about drawing what you see in front of you. Once you have an understanding of these facts, you can alter the way in which you apply them to your work as appropriate.

The four basics that you need to know about are: composition, perspective, tone and shadow. They are applicable to all subjects and all materials, but we shall look at them here with special reference to the scope of this book. I have described and illustrated these facts in separate sections, but all four elements interact with each other in the production of a complete picture.

COMPOSITION

When you look around and see what lies before you – whether it is a landscape, a street scene or a garden – your eyes can appreciate quite a wide view. However, in order to reflect the interest that drew you to the scene in the first place, you will need to select the most suitable part to draw. This selection, and the arrangement of parts within it, is called 'composition'.

People sometimes say, even when they are in an interesting and varied location, that they cannot find anything to draw. What they really mean is that what they see is too difficult for them to cope with at their stage of drawing. This is quite understandable;

practice will eventually lead to a level of competence that will cope with complicated subjects, but this will take time. It is often difficult to persuade anyone to forget gorgeous wide landscapes or intricate streets in favour of small details, but sometimes a small part of a landscape or town can form the basis of a finished picture in due course.

Choosing a focal point

Having chosen part of your landscape or townscape as your subject, you will now need to indicate its main points of interest,

Focusing on details

A single boat by a jetty with just an outline of buildings beyond can make a picture of a recognizable place without having to draw the whole harbour or quayside. Alternatively, a field gate with a few wild flowers typical of the district and season, with some distant rolling hills and a church tower, grain silo or other large building, can accurately depict a well-known location.

Two examples showing where a focal point could be drawn at the crossings of the divisions of 'thirds' (see page 45).

Acceptable alternative compositions

These illustrative diagrams show some interesting departures from the division of 'thirds' guidelines (see page 45). For example, a tree on rising ground in a distant landscape will fit into an L-shaped composition, whether landscape or portrait. If a waterfall is directly in front of you, it can give a sense of drama when it nearly fills a vertical format. Also, a church on a hill can fit attractively into a triangular composition.

Above and above right: These two sketches show how placing a tree in an L-shaped compostion helps to give a feeling of balance to a picture.

Above: Central, but because the waterfall is larger than its surroundings this composition gives a dramatic effect.

Above: Central, but your eye is drawn to the church by the shape of the hill, which makes a triangular compostion.

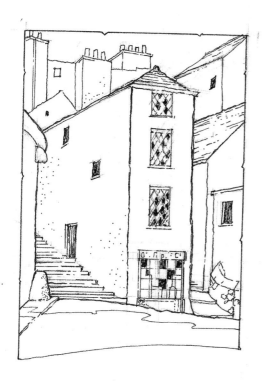

Above and right: These sketches show how to add a feeling of welcome invitation into a scene. Any attractive picture, however small, will invite you to look into it closely, but sometimes, little additional parts can take you further. These invitations do not necessarily lead to focal points in pictures, but give added interest without detracting from the main interest of the picture.

and there are some aspects that you should consider when composing your picture. These guidelines have evolved through the behaviour of the human eyes when they look at something. For example, eyes can convey a restless feeling if faced with conflicting points of interest, so it is generally a good idea to create a focal point to act as the point of main interest in your picture.

Over the years, the selection of a focal point has been the subject of differing theories. One view is that a composition works well when the eye moves around it instead of being focused in one place. This is particularly relevant to a large picture with lots of interesting things happening in it, where the eye would need to be directed back to the starting point.

Sketching Landscapes in Pen and Pencil

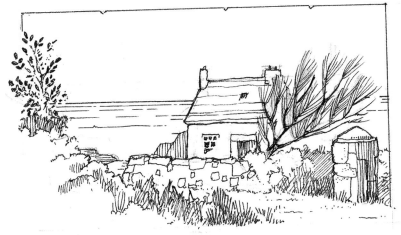

Left: The path by the large stone entrance pillar invites you to go past the cottage, with its windswept tree indicating coastal gales.

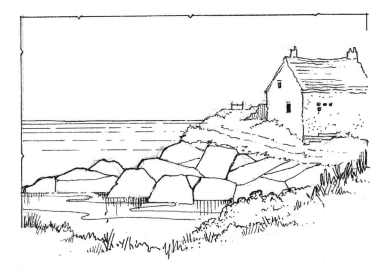

Left: This is a beach scene with the rocks giving important foreground interest while being low enough to see over. The coast path leading past the cottage and over the hill gives a further invitation.

Below: This is a small stretch of beach by a river flowing quietly through the countryside. The rough stone wall runs out into a sandy shore and forms a base for the picture. There are low rocks and grass on the foreshore and the river is easily accessible for splashing about. Small boats use the river and it is an inviting scene on a sunny day.

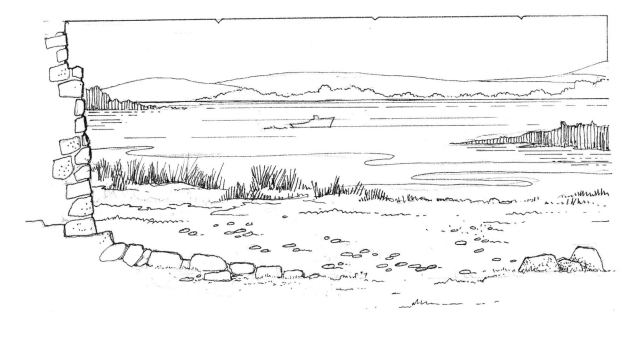

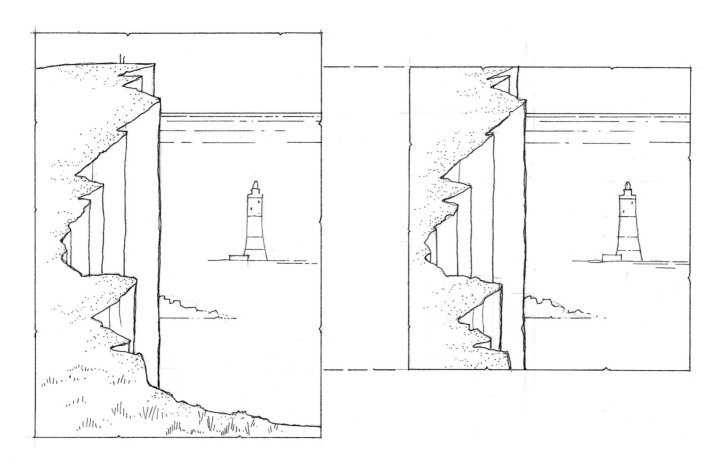

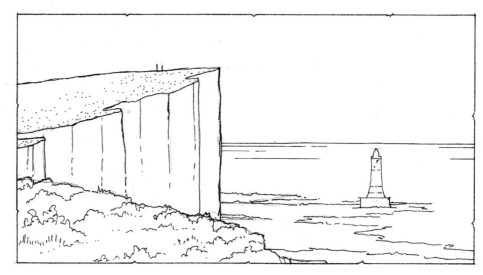

These simple outline sketches show different ways of treating the same subject in order to give feelings of stability or instability. The sketches are based on an area in the south of England, but the techniques are relevant to cliff faces anywhere, including inland escarpments.

The view on the top left gives a fairly safe feeling, and the vertical format emphasizes the strength and solidity of the cliff. However, cliff edges usually conjure up doubts in the mind regarding safety.

The second view (top right) is a cropped version of the first sketch that alters the scene to give a strong and dramatic feeling of instability. You cannot see the people in safety

on the top of the cliff and the lower part goes right off the edge of the sketch; no safety here.

The sketch above loses the dramatic impact of the first two, but gains a sense of stability and comfort.

The horizontal format is more serene than the vertical in this case. You feel that you can actually reach the beach itself because there is an indication of the ground below. The low tide even robs the lighthouse of some of its mystery.

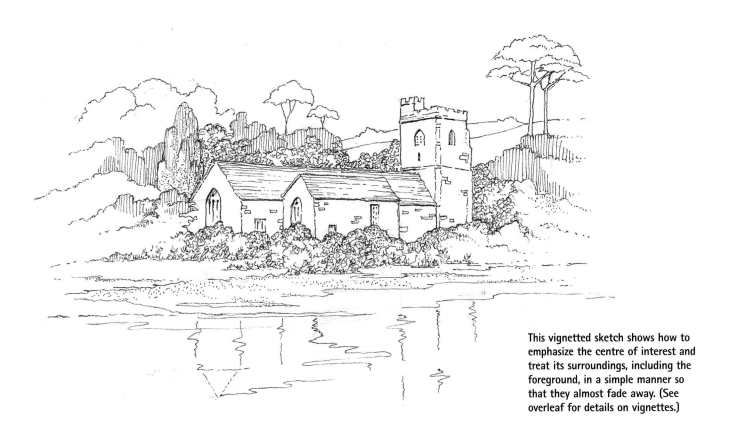

This vignetted sketch shows how to emphasize the centre of interest and treat its surroundings, including the foreground, in a simple manner so that they almost fade away. (See overleaf for details on vignettes.)

However, in the case of small pictures such as those made in pen or pencil and derived directly from our sketchbooks, and where the proposed image is likely to be quite small, too many points of interest can be confusing.

So, where do you place this focal point? Studies of pictures have shown that a main point of interest selected at about one-third of the way up and about one-third of the way across a landscape or townscape has worked well. A departure from the 'thirds' guideline can be used to evoke certain responses in the person looking at the picture, and some artists have placed their centres of interest to create a mood of excitement or intimacy.

People usually like to perceive a sense of stability when looking at a drawing. To achieve this, you can incorporate a strong base to your picture by including an item such as a wall, fence, group of large rocks, and so on. However, if you wish to evoke a dramatic feeling, you can emphasize depth, grandeur and instability by using a vertical format and letting the eye run down and out of the picture. On the other hand, you can create a pleasant feeling of an inviting association with a scene by leading the viewer into it directly, perhaps by a country lane or village street, or over a few low rocks on a beach.

Balancing shapes

You should be aware of balancing positive and negative shapes in your composition. Negative shapes are made by the places between your various known items.

Compositions to avoid

 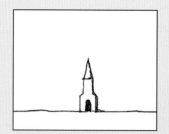

Above and above right: Do not place your main subject so that it is overpowered by its surroundings whether these are blank areas or complicated ones. An L-shaped composition can be helpful.

Above and above right: In this example, alter your format to give emphasis to the church so that it is no longer dominated by its surroundings.

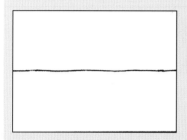 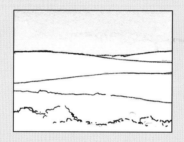

Above: Avoid dividing your picture exactly in half (as shown on the left), as this does not generally produce an interesting composition. Instead, alter the dividing line and give emphasis to either the lower part (in this case the countryside, centre) or the upper part (in this case the cloud formation, right).

You do not always need to include an area of sky. Taking your stand on a small hill and looking down into a scene can focus attention on your immediate surroundings, but it will be necessary to include some foreground to give scale and stability. You will also need to consider perspective carefully, because your eye level will be high.

However, there are some arrangements that you should avoid when composing a picture. For example, do not place the subject on the centre line of your picture so that the equal areas on each side completely dominate it. Compare with the acceptable arrangements mentioned earlier (see page 41) where the centrally placed subject is important enough to dominate its surroundings.

Equally, do not divide your picture exactly in half with a continuous horizontal line (for example, the sea or a distant skyline of trees and bushes). A centrally placed division of this type could work in some cases if the sky is very plain and the foreground full of interest, or if there is a glorious cloud formation above a plain stretch of land or sea. But it would be better to increase one or the other to give a more pleasing composition. When you do this, be careful that you do not make both areas competitive in their appeal. For the same reasons, do not divide your picture exactly in half vertically, unless there is a build-up towards the central feature so that the composition is resolved into a triangular shape (as shown in the sketch of the church on page 41).

Vignettes

You do not necessarily need to use the whole area of your paper by drawing right to the edges. Creating what is called a 'vignette' can give a really interesting result. One definition of a vignette is an illustration that is not confined by a definite border. In our case, this means confined by the edges of a sheet of paper.

The edges of a vignette should lead into the centre (or centres) of interest in your picture. You might draw the main interest in your picture in a detailed way, and then use less detail and, possibly, finer lines as the image spreads outwards into the surrounding blank areas of your paper. It can be interesting to integrate pencil work here if you are using pen for the main part.

Sometimes, parts of your drawing will have interesting edges in themselves, such as those formed by foliage or pebbles or perhaps by the interesting outlines of foreground structures. While not making true vignettes, the edges of which fade into a background, these interesting edges make good pictures. (Some of the illustrations in this book have edges treated in a non-confining way, which adds to the picture.)

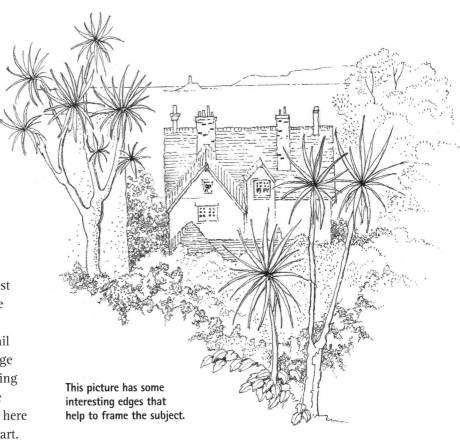

This picture has some interesting edges that help to frame the subject.

Creating a successful vignette

Just leaving areas of blank paper around a drawing does not necessarily make a vignette; the areas of blank paper need to blend in with your picture and contribute to its effect. They also need to link it visually with the bare areas of paper within the picture itself.

If you are making a sketch with the idea of developing it later on, you might like to think about the possibility of producing a vignette if the subject suggests it. Think about whether the edges of your sketch will blend outwards into your blank background or whether your picture will be better contained within itself. An example of this last situation would be where the edges are defined by definite items; these could be buildings, walls, tree-trunks, and so on.

If you are looking at a group of objects to include in a still life, such as fruit, flowers, shells or pebbles, the main objects will make the point of interest against a gently fading background (see page 132 for more details on sketching still-life subjects).

PERSPECTIVE

The purpose of perspective is to produce a feeling of depth in your drawings. However, the word 'perspective' worries a lot of people, perhaps because they believe a detailed knowledge of geometry and accurate measurement is required to cope with the appearance of buildings in a landscape or townscape. This detailed knowledge is certainly required when an architect or engineer is using a series of plans to show the appearance of a proposed structure. However, some basic points of perspective can be clarified by simply looking at a scene, and the artist at least has the advantage of seeing the actual structure he or she wants to depict!

Linear perspective

The sketches on this and the following pages give some examples of perspective, and include lines indicating the positions of eye levels (shown in green) and major vanishing points (shown in red) in various situations. Bear in mind that these will change if you alter your own position.

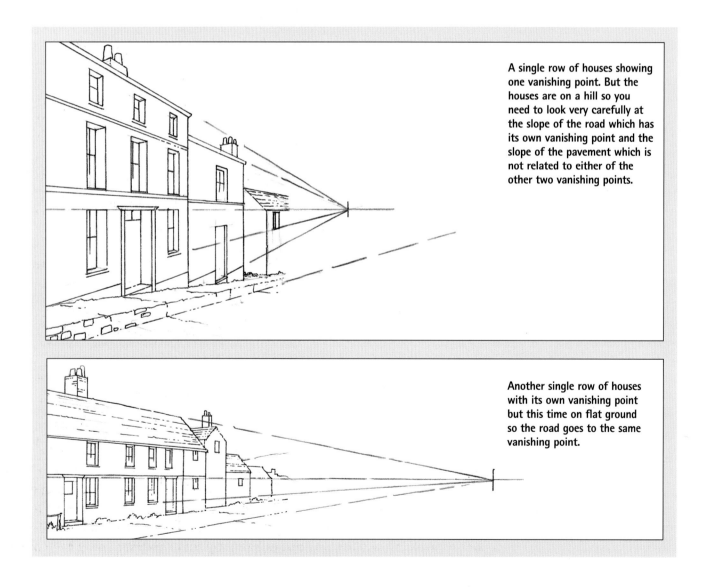

A single row of houses showing one vanishing point. But the houses are on a hill so you need to look very carefully at the slope of the road which has its own vanishing point and the slope of the pavement which is not related to either of the other two vanishing points.

Another single row of houses with its own vanishing point but this time on flat ground so the road goes to the same vanishing point.

One- and two-point perspective

One-point perspective If you are sketching in a large courtyard or other open space in which the main object is parallel to you, the lines of other buildings, if at right angles to you, will all converge at a single vanishing point, and this illustrates one-point perspective.

Below: An courtyard showing one-point perspective where the opposite buildings are parallel with each other.

Two-point perspective If you are in a location where the main subject is at an angle to you, it will have two vanishing points: one for each face of the object as it goes away from you. This illustrates two-point perspective.

Below: A large courtyard area showing both one-point and two-point perspective. The building that faces you on the right is not quite parallel to the rest of the street, so it has two vanishing points (the second shown in black), one of which goes off the page and into the far distance.

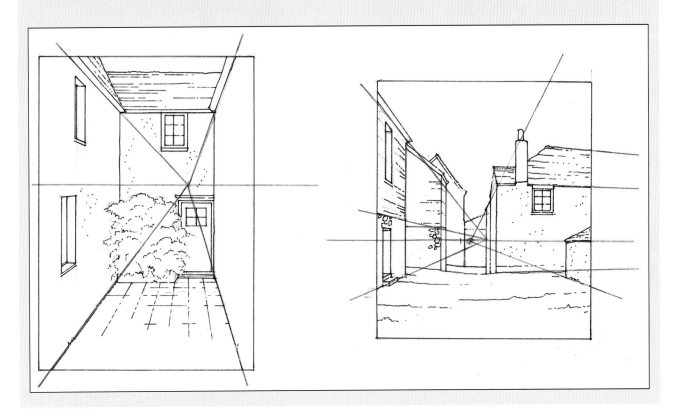

The vanishing point

When you look at a scene or object, the point at which extended lines converge is called the 'vanishing point'. (A complex scene will probably contain several objects – for example buildings – and these will all have different vanishing points.) The vanishing point is always on your eye level, which is found when you look straight ahead. This means, in practical terms, that you should stay in one position when you are sketching. You will look up and down while you are sketching, but your eye level relative to the objects in your scene will not change. For this reason, it is a good idea to draw a horizontal line on your paper when you have decided where to sit or stand.

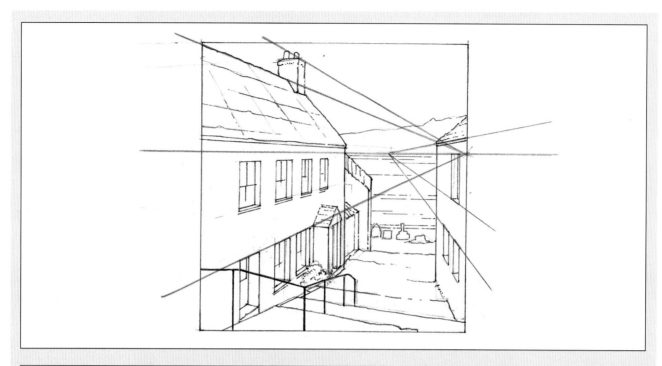

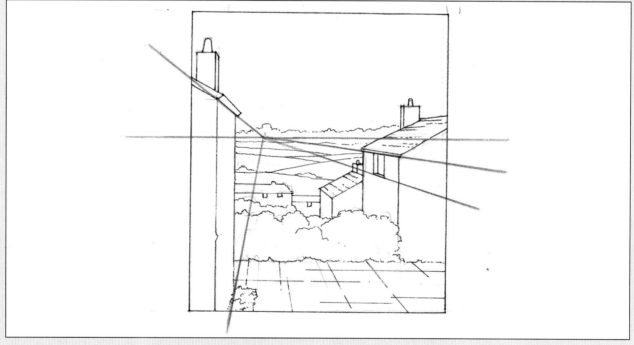

This page: Both of these sketches illustrate perspective when drawing from a high vantage point. The top sketch is taken at a high eye level (at the top of a street), and shows different vanishing points because the opposite sides of the street are not parallel. The bottom sketch is also taken at a high eye level (from a flight of steps), but is a view of an open area showing one-point perspective, with a vanishing point relevant to the main buildings.

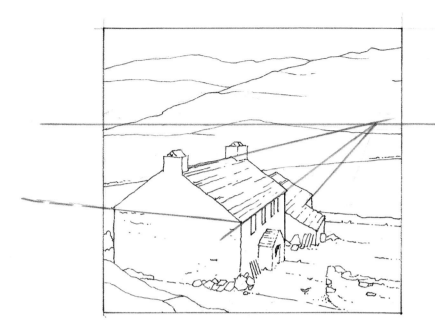

Left: Here is a single house at an angle to you and viewed from rising ground, so your eye level is high. The vanishing point on the left goes off the paper and into the distance because you are standing where your viewpoint gives this situation. If the vantage point had been moved to the right you would have seen more of the right-hand wall and the vanishing point would have been different.

Below: A single house at an angle to you on flat ground thus showing two vanishing points in two-point perspective. The eye level is just below the height of the front door. You are standing so that the two vanishing points are about equal distances from your own viewpoint.

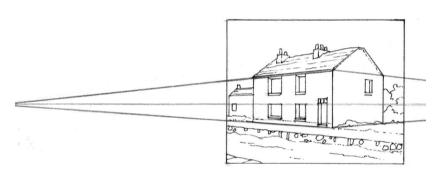

Converging verticals

There is another application of vanishing points: if you stand at the base of a tall building and look up, the walls will appear to slope inwards as they go towards the sky. This is known as 'converging verticals'. If your subject contains cylindrical objects (for example, round towers, cups or vases), you will need to know how the tops and bases appear in perspective. These will be in the form of ellipses (unless the top of your vase or cup is right on your eye level, when it will appear as a straight line), and the ellipse at the top will not be as full as that at the base.

Assessing vanishing points

When drawing any scene, you need to be able to assess the slopes of the lines that converge at the vanishing point. A practical way of doing this is to take your pencil and hold it at arm's length at an angle until this angle coincides with the slope you are looking at. Keeping the pencil at this slope, carefully bring it down to rest on your paper. Finally, hold it there, take another pencil and draw lightly along the first one to give you the line of slope.

Types of perspective

It is not always realized that there are two types of perspective of interest to artists. These are 'aerial' perspective and 'linear' perspective. 'Aerial' perspective deals with the influence of atmosphere on distance and colour, while 'linear' deals with the appearance of buildings and other structures, large and small, near or distant, as well as roadways, railway lines and seashores.

Aerial perspective Aerial perspective is created by dust particles carried in the atmosphere, which block the light as it travels. These particles combine with drops of moisture to scatter the light rays and make distant objects look softer than ones nearer to us. Distant objects also change in colour and tone. For example, far-distant hills and trees can have a bluish-grey colour. It is important to realize that the clarity of the atmosphere will vary according to the region and season.

Aerial perspective presents some special challenges when it is to be depicted with pens or pencils. These cannot produce graded washes or glazes of colour, so they depend on the quality, thickness and distribution of lines and other marks to give the required effect. In this sense, pencil is a sympathetic medium because soft, graduated shading can be used to give the impression of fading distance. With pens and inks, dots and lines at different spacings must be drawn. Alternatively, pens with water-soluble inks can provide softer edges and so can be used to give recessions in depth. Water-soluble graphite pencils are also helpful in this respect.

Linear and planar perspective Linear perspective is based on the simple fact that objects, and the edges of objects, look smaller the farther distance they are away from us. Noticing how objects overlap each other as

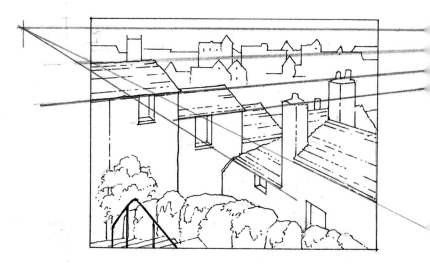

Above: Here, you are standing on steps in a little area right above the main part of a small town so your eye level is very high. The far-distant buildings have been very simply outlined because they do not show linear perspective to the degree that is relevant to the sketch. (However, it is a good opportunity to show simplification that gives distance to your picture.)

they recede can also create a sense of distance in a sketch. This is known as 'planar' perspective, and is usually quite apparent when we look at a scene.

The type of scene you are looking at will indicate the amount of depth that perspective will give to it; a small courtyard will show very little depth, while a distant landscape will show a great deal.

Basically, you need to emphasize the foreground detail, be it grass or a cobbled street, with one type of line. Then, as the land or street recedes further into the distance, use a thinner line and include less detail. Finally, use a very thin outline or a series of fine vertical lines to indicate the far distance, perhaps just the tone of hills or trees,

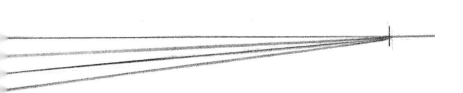

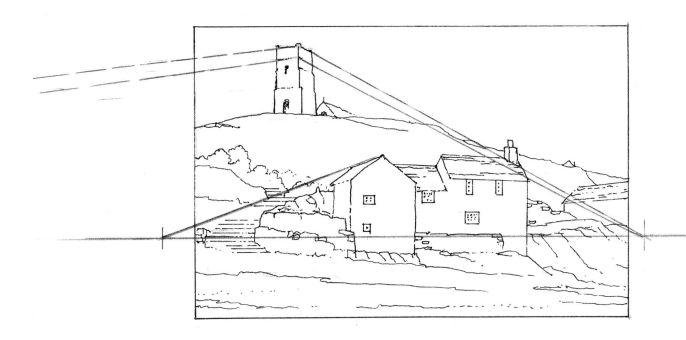

headlands or distant towns or villages. As an alternative, you could use soluble inks and pencils or ordinary pencils to produce soft shading in these far distances.

When you have looked at a few scenes you will notice that the angles at which your extended lines meet the line of your eye level vary in steepness. Take a house, for example. If it is near to you, the angles of its roof will appear to be very steep in relation to your eye level, but if it is far away you might hardly notice any slope at all.

Perspective in a scene

It is possible can create a technically correct drawing by learning the theory of perspective, but I am taking a slightly different approach where you already have the scene in front of you. The ability to draw what you actually see, and not what you feel should be there, is always important; this is particularly the case when you draw lines, angles and areas in perspective. It is often quite difficult to draw a line at the correct angle because you might not have yet developed the ability to relate this to its surroundings, but if you understand the theories underlying perspective you will come to apply them automatically when sketching a subject.

Reflections

Reflections in water can form an attractive part of a composition. If the object you wish to reflect – for example, a pole – stands right in water or at the water's edge, it will reflect an exact image straight down into the water, except for any ripples in the water which will distort the image. If the pole leans to one side, then the reflections will still be the same length, but at an angle. If a building is on the water's edge, it will reflect its whole image straight into the water, but if it is set back, perhaps in a flat field or on a bank, not

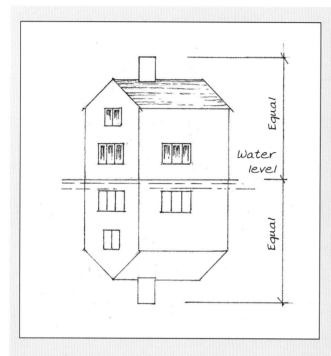

Reflections

These diagrammatic sketches show how perspective can affect reflection in water when the building or other structure is straight in front of you. Reflections will vary if you are higher than your subject or relatively close to it. The diagrams showing houses and posts give clear outlines of their reflections but in reality any movement of the water will affect the clarity of the reflections. This sometimes produces pleasant images.

Left: This house is situated right on the edge of a stretch of water so its reflection is a straight copy of it (but, of course, upside down).

Below left: This house is set back from the water's edge and you need to look carefully to see how much of it is reflected in the water. Just be aware that this is the case.

Below: This post with its reflection is shown both upright and at an angle.

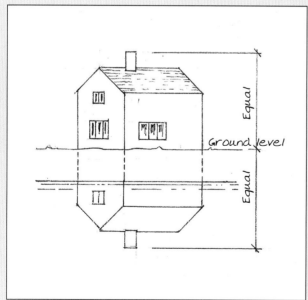

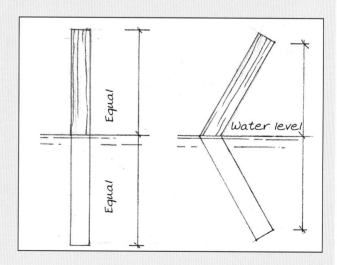

Sketching Landscapes in Pen and Pencil

Below: The two images below give further variations of how perspective can affect reflections. The first (below, right) shows a structure, perhaps the base of an old fortification, rising directly from an area of water. It is situated so that it is standing at an angle to you, the viewer, and as a result it has two vanishing points. I have also drawn a building at an angle to you. Again, it has two vanishing points, but in this example the structure is set back from the edge of a small stretch of water, creating a slightly different reflection.

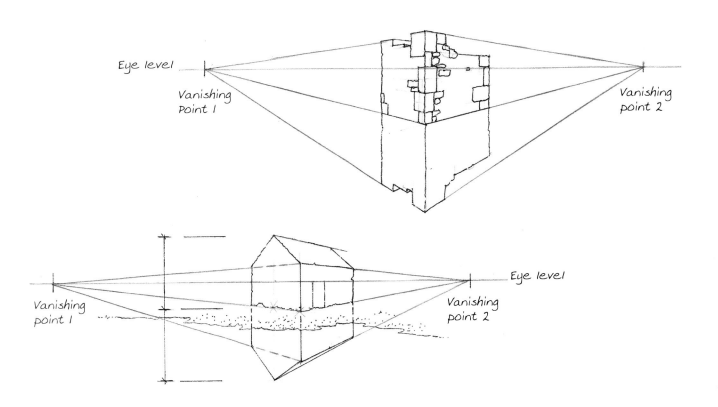

Right: Boats need to be drawn with due regard to their lines of perspective and so do their reflections. If you are looking down on a small boat – perhaps from the side of a harbour – you will see part of its underside reflected as well.

This sketch shows that the lighting was very bright, but, because of the position of the sun, the shadows cast by the overlapping boards were very thin. However, the reflection shows the shadows on the undersides of the boards and defines them clearly.

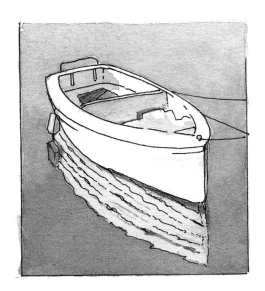

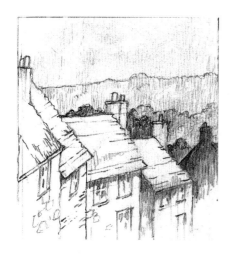

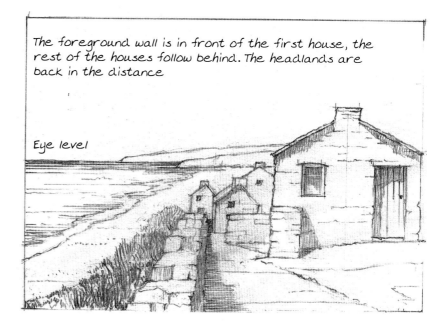

The foreground wall is in front of the first house, the rest of the houses follow behind. The headlands are back in the distance

Eye level

aAbove: This simple sketch shows the principles of aerial perspective. Buildings in the foreground have been drawn with detail while trees in the background diminish in tone as the country recedes.

Above: This illustrates planar perspective, where distance is indicated by subjects being drawn one behind the other and with different emphasis on each group.

Below: How perspective affects the appearance of gentle waves where they meet the beach. (For further illustrations of waves see pages 128–9.)

Below: This shows the principles of linear perspective shown in a beach scene.

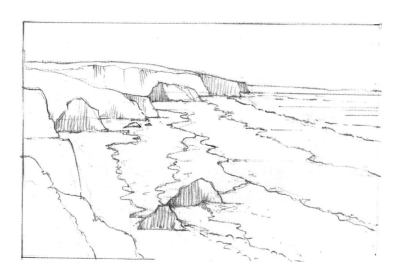

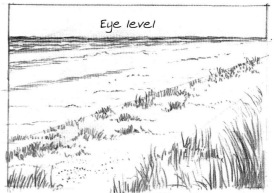

Eye level

Use pencil with upward strokes for foreground grass

all of it will be reflected. Your view of it will depend on your eye level and the distance you are away from the water's edge. You might be sketching on the opposite bank of a wide stream, or from a small boat mid-stream. Because there will be many variations relevant to such reflections, the best way to tackle these problems is to look carefully and draw what you see, taking into account how the physical aspects of landscape can affect reflections of objects in water.

TONE

Tone (or 'value' in the US) refers to the degrees of lightness and darkness in colours, relative to each other. Artists sometimes find it difficult to appreciate tone when they are looking at a colourful scene in front of them, but the understanding and appreciation of the contrasts between light, medium and dark tones will contribute to the making of interesting pictures.

Tonal composition is the arrangement of light and dark areas in a drawing. It is necessary to remember that, if you are sketching out of doors, the movement of the sun will affect these areas. If you already know a site and have a choice of times when you can visit it and an idea of how you wish to interpret its mood, this will be very helpful. Of course, if you are only able to make one visit, you will need to take the conditions as they stand – you might be inspired by what you find!

Tonal interpretation

The rendering of colour into tone is of particular importance to the artist working in pen or pencil. A drawing made by using either of these materials will have a more limited tonal range than one made in full colour. This is because the character of pen or pencil drawings relies completely on the contrast in tones for its success. If you try to include too many tones in a pen or pencil drawing, it can look flat and unappealing. The tonal interpretation of a scene to be painted in full colour will show many gradations. If the scene is to be drawn using pens or pencils, the range is probably reduced to about five tones.

Colour and tone relationships can best be explained by looking at some specific examples. Yellow, in itself, is a pale colour and so it has a light tonal value. Browns and reds, in themselves, have dark tonal values. You will see that I have said 'in themselves'; when viewed in a landscape, townscape or still life, the tone of the colours will be affected by any light falling on them. Shadows will alter tonal values, making colours appear darker, and direct light will make them appear lighter. You could have a situation where a yellow colour in shade could have the same tonal value as a medium-brown colour in full sun. So, when looking at a scene, it can be difficult to appreciate the differences between the effects of tones derived from the colours themselves and how light affects them.

To take an example, a scene could comprise an open stretch of beach with a rippling sea, a distant headland and large rocks in the foreground. On a moderately bright day with slightly hazy sunlight, this could present an attractive picture if it was recorded in full colour. However, the tonal range could be very limited: a light blue sky, a light greenish-blue sea, dull yellow-brown sand and light brownish-grey rocks. If the scene was viewed in bright sunlight, the sky would be brighter and darker, the sea would have more contrast, and the rocks could cast strong shadows. As a result, the differences in tones throughout the scene would be more easily understood.

Tonal ranges and tonal textures

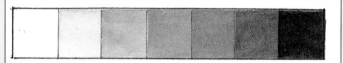

Watercolour washes giving seven tones

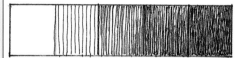

Vertical pen lines used to give five tones

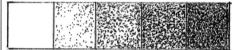

Dotting with a pen to give to give five tones

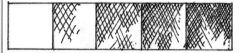

Cross-hatching drawn with a pen to give five tones

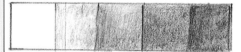

A range of five tones made by the use of an HB pencil

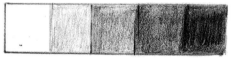

A range of five tones made by the use of an 2B pencil

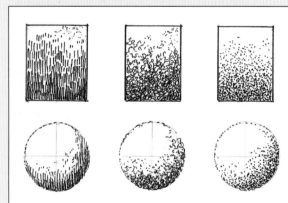

These sketches show graded tones and indications of forms in various situations

The use of tones to give form

Here, rather obviously, is a circle. What does it represent? Unless it forms part of a geometrical exercise it needs tone and shadow to explain its form.

This circle could be a flat disc, for example, a coin lying flat upon a surface. When drawing it, you can keep its firm outline and add a cast shadow (in this case the light is coming from the left). Add a background tone of dots or lines to represent the surface on which the coin is resting.

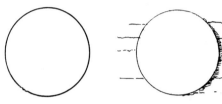

This time the circle is turned in into a sphere, for example a soft ball resting against an upright background. Do not draw a firm outline, just indicate its outline by very faint pencil marks to be erased later. Add graduated tonal shading to define its form. The addition of cast shadows and a patterned background further assists in suggesting roundness and solidity.

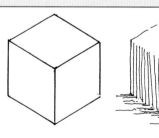

This shows a pattern of diamond shapes, a motif widely used in ornamentation, the edges of three diamonds forming a hexagon, which is often used in traditional patchwork design. I have added tone made by the light coming from the top left to create a box standing on a textured fabric. The shape of the cast shadows will depend on the particular position of the light.

Right: This sketch shows that you need not always include the whole of the sky. Here, the background of trees shows up the white houses and the light on the river and the road. I used an HB pencil to give a gentle look to this fairly high-key sketch and used the side of the pencil to give a tone over the trees.

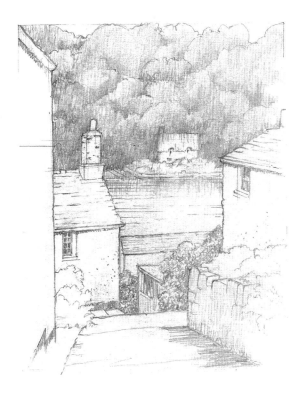

Tone, shape and texture

The expression of form is necessary to show the actual shape of an object. This is usually quite apparent when an object has hard edges enclosing shapes that can be emphasized in outline or by shadows, but many things, whether they come from the natural world or are man-made, do not have hard edges. When you are drawing these in a representational way, it will not be appropriate to enclose them with an outline. For example, a circle could indicate a coin or a ball. Therefore, in the cases where you have rounded forms you will use tone to indicate disappearing edges. This can be more effectively shown when your object is set against a background or next to another object with different tones.

You can show texture by using tone to represent shadows cast on a wide variety of surfaces, like orange peel or uneven ground. The tones of cast shadows are usually darker than the tones of the objects that cast them.

The depth and distribution of tones on an overcast day will be different from that on a sunny one and so you can use them to express different moods. Tones at the darker end of the range can give a stormy look, indicating high winds, choppy seas or heavy industry. These effects are called 'low key'. However, low-key drawings do not necessarily indicate a sombre mood; they can be made to give a feeling of strength or mystery. In contrast, tones at the lighter end of the range can give a calm and gentle look, indicating breezes, ripples on the sea and sunny summer occasions. These are 'high-key' subjects.

SHADOWS

Shadows are formed by the action of light on a subject. The stronger the light, the more contrast there is in the tone of the shadows occurring in the subject itself and those cast by it. Sometimes, the shadows of objects are interesting in themselves. The patterns cast by ornamental metalwork can make interesting focal points in pictures.

Shadows will appear to have hard or soft edges depending on the intensity of the light. They will be hard edged when the source of the light is clear and bright, as it can be on a very sunny day, and soft edged when the light is diffused through clouds by an overcast sky.

As I have mentioned before, drawings made with pen or pencil rely on tonal contrast for their success, and shadows play an important part in the tonal composition of a picture.

The direction of light

Maximum impact can be gained in sketches by setting dark areas against light ones (and light against dark), and textured ones against those that are plain. However, the direction in which light falls will affect the way in which the form of a subject can appear at different times. The effects of this direction are most apparent in near and middle-distance outdoor subjects. As we have seen in the section on perspective (see page 48), the appearance of objects becomes less distinct as they recede into the distance, and this applies to their shadows as well.

If your subject is in the near or middle distance and has a definite form that needs to

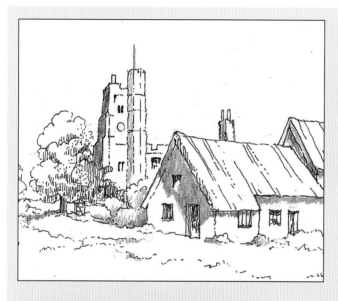

Shadows and the direction of light

The purpose of these sketches is to show how the direction of light throws shadows which affect the forms of buildings in their surroundings. If you can visit a place more than once, you will be able to choose the time when the light will give you the most interesting scene to sketch.

Left: Here are thatched cottages and a country church with the light coming from the front right. It shows particularly well the form of the church and the undulating overhanging edge of the thatch.

Below: The light here is coming from the left and slightly behind you. The houses on the left have interesting patterns of half-timber and it is unfortunate that they are in the shade while the plain house on the right is brightly lit. If there isn't a convenient place to sit while sketching when (and if) the light goes around to shine on the left-hand building, a photo from that position could be useful.

Below: These little thatched white-walled cottages are very similar on both sides of the road and the direction of light will give similar effects, whether it comes from the left or right. Here the light is coming from the front right. Remember that the time of day will govern the length of the shadows.

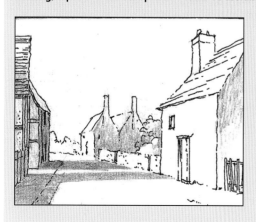

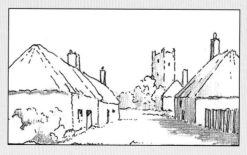

Sketching Landscapes in Pen and Pencil

Drawing shadows

When you include shadows in a sketch, do not draw firm lines around them even if they have hard edges – indicate them with linear strokes or stippling, by using water-soluble inks or pencils, or by graded pencil in a pencil drawing. The intensity of your shading will depend on the overall disposition of tones in your drawing. There are several ways in which direct light can fall upon a subject, and I will describe these in relation to one nearby tree.

Top light Overhead sun casts shadows directly beneath the tree and does not give an adequate impression of its form.

Front light This is light coming from behind the artist and casts shadows directly behind the tree. The tree itself looks very flat, with little or no modelling.

Side light This throws the opposite side of the tree into deep shadow and also creates a deep cast shadow. It can give a three-dimensional effect of solidarity.

Back light This type of lighting, apart from being uncomfortable for the artist without wearing sunglasses, throws the tree into a silhouette, obscuring detail and modelling. This can be attractive if the tree (or other subject) has an interesting outline; otherwise it does not define its form.

Angled light When this falls at about 45 degrees (i.e. a three-quarter light), this gives the most information about the form and texture of the tree.

Top light

Front light

Side light

Back light

Angled light

Cast shadows

Cast shadows also bring out the very positive textural qualities of the surface of some materials when you look at them fairly closely. In the following examples a strong light is coming from the left. The first sketch shows a Portland limestone wall built of roughly shaped stones laid in courses about 3ft 3in (1m) high. Where the shadow falls it shows individual stones and jointing because these can appear more visible when we look closely in the shade.

Do not draw every stone and joint in the rest of the wall, because the effects of the light will be diminished.

In the second sketch, the shadow cast across the beach indicates the uneven surface of the pebbles. The timber posts are remnants of barriers to stop the pebbles from shifting. The horizontal timber on the left is part of another beach structure. The position of its cast shadow indicates that it is not resting on the ground.

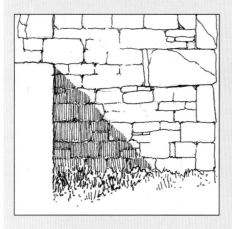 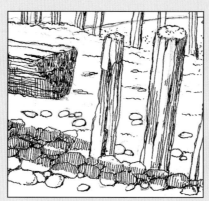

These sketches show a simple form of painted weatherboarding (clapboarding in the USA) where the boards overlap to cast horizontal shadows which emphasize the surface. The boards are usually butted up against vertical corner posts and the shadow cast by this post upon the sloping surface of the horizontal board varies in size, as shown in the more detailed close-up sketch (below right).

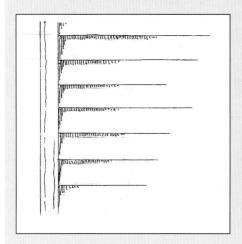 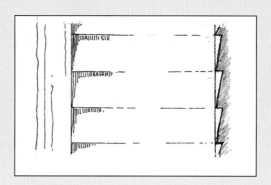

Cast shadows are drawn here to indicate how they affect the shapes of the ground and the texture of the surfaces.

Right: The light is coming from the right and casts the shadows of a fence and trees on to a rough and rather stony country lane.

Below right: The light is coming from the left and casts the shadows of trees on to a smooth, recently laid tarmac path; it continues and shows the shape of the slightly rising ground opposite. Also, because the shadow of the front tree on the path appears to be disconnected from the tree itself, this indicates the position of a bank this side aswell.

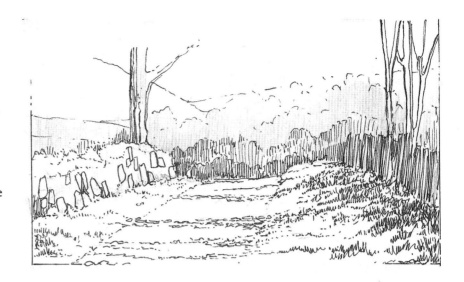

be described, such as a building or other man-made structure, it is particularly important to consider the direction of the light, because the light will help to describe its form. Of course, the structure itself might have decorative sculptures or other ornamental work which themselves give interesting shadows, and you might like to concentrate on these and make detailed drawings of them.

Shadows and texture

Cast shadows can describe the surface on which they are falling. This could be a paved path, the uneven surface of a road, or a pebble beach. The use of cast shadows is also helpful in describing the form of building materials when seen close up, such as stones in a wall. Although the tones of cast shadows are usually darker than the objects that cast them, this will depend on the intensity of the light and the tone of the object that is casting the shadow.

If you are sketching indoors, you can use a window for an unchanging direction of light,

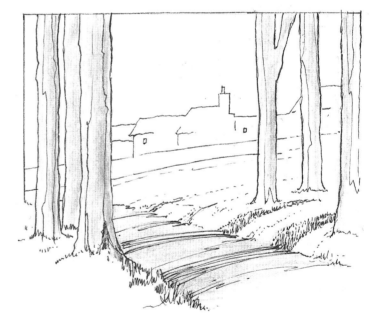

although its intensity will change throughout the day as the source itself moves around. If you are drawing a still life indoors, you can use a lamp to set the direction and intensity of light that you require for your subject. I have written about this aspect in the chapter on *Still life* (see page 132).

Colour

Colour

Throughout this book, you will see how the selection of subjects particularly suited to the use of pens and pencils can result in pictures of character and feeling. However, for some subjects, colour can add a further interest. With practice, when observing your subject you will know before beginning your sketch whether pen or pencil work should stand on its own, or if you feel that the addition of colour would be attractive. You will then need to decide how best to balance the effect of both materials in your proposed picture.

Making notes on colour

If you are making a quick sketch with the purpose of working it up later as a picture with colours, you will need to use some colour samples or make some notes to describe the colours you think you will need. Any description of a colour needs to be specific. For example, it will not be very helpful to be faced with single words like 'green' or 'brown'. Practice will help in the description of colours, but until then it will be useful to make some simple reference pages and keep them in the back of your sketchbook. Make two: one giving samples of coloured pencils with their numbers, and the other with samples of watercolours with their

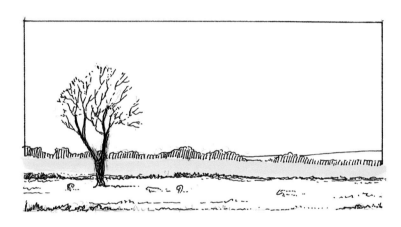

A simple pen sketch of a field of oil-seed rape with one bold sweep of colour added.

names, ('olive green', 'burnt Sienna', and so on). Refer to these lists and match the nearest sample colour to that in the subject. By all means take a photograph as well, but bear in mind that different development processes can give different colour results in a print.

Pen and wash

The oldest way of adding colour can be seen in topographical pictures made by long-ago artists including Claud, Turner, Sandby, Jacob van Ruysdael and, closer to our time, Edward Lear (1812–88). The older of these artists used quill pens and a substance called 'bistre', which was a liquid made from soot.

Applying colour to trees
The treatment of trees will depend on that in the rest of your picture. A scene where the trees are acquiring rich seasonal colours will concentrate on these with just a few indications of their outlines. Trees such as the cedar of Lebanon and the Lombardy poplar are interesting because of their shapes, and these can be slightly emphasized with just a wash of grey-green or green colour run over them.

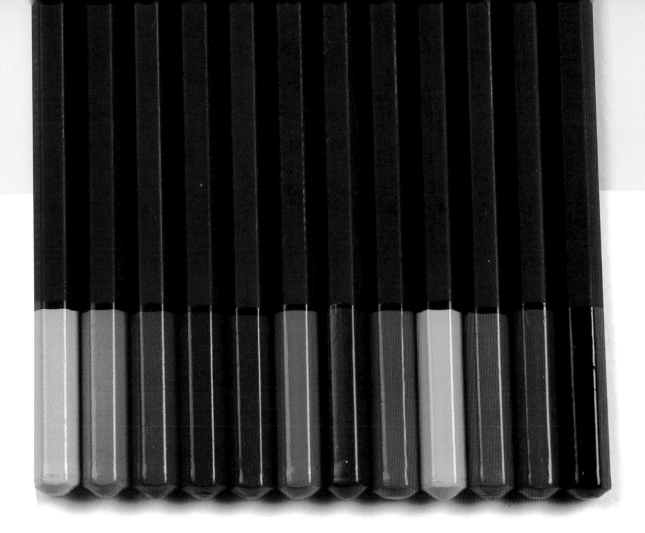

Colour materials

The usual coloured materials used in conjunction with pen or pencil sketches are ordinary coloured pencils, water-soluble coloured pencils and watercolour paints. Whereas the use of ordinary coloured pencils can be helpful in adding colours or colour notes to your sketches, they are also used to make quite beautiful images in their own right.

Nowadays, a technique called 'pen and wash' is much more common as it can be used in a free and creative way. It differs from a pen-and-watercolour drawing, which is more precise and needs to be delicate in tone to prevent it from becoming overpowering. Subjects that readily suggest themselves as suitable treatment for pen and wash include buildings, street scenes, old railways, cars and industrial areas. An early twentieth-century artist who produced delightful pen-and-watercolour drawings was Sydney R. Jones. Present-day artists who use the free pen-and-wash technique include Paulette Fedarb, Claudia Nice and Margaret Evans.

There are several things you should remember in order to produce a successful pen-and-wash image. Most important is the relationship between pen and colour. The effect of their uses should not give a confusing message. Either colour or line, texture and pattern is the more important, but do not try and give equal prominence to both.

For example, a street might contain several buildings that, because of their different periods and uses of building materials, are all especially suitable for pen-and-ink detailing.

Perhaps just one house is a different colour or some have different coloured doors, and you could pick these out in colour. Or, a street could have several colour-washed buildings with different roofing materials, and you could concentrate on washes of colour with just a few lines to depict the roofs and the edges of the houses.

Using colour washes creatively

When you run colour washes over your sketches, they can be quite loose, letting the white paper show through in places. Alternatively, you might see something, perhaps a view or a group of objects or fruit, which has distinctive areas of colour. It can be interesting to run a varied colour wash over the paper, picking up the coloured areas and letting them blend together. Let the colour dry and then draw into it.

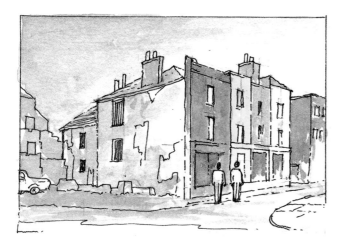

Above: This shows a small corner of a city where the residents had brightened their street in an area where some rebuilding was to take place. This sketch, with its careful addition of colour, makes a little record of their endeavours.

Using colour in detail

You might come across a scene that you think calls for the addition of colour in a more precise way. This could be because the colour is concentrated in one area or confined within precise shapes. In this case, draw your scene in outline and add blocks of colour. You could also indicate any muted background with a free wash. This type of treatment is quite suitable for small sketches (on a sheet up to A5), but would lose its simple character in any larger image.

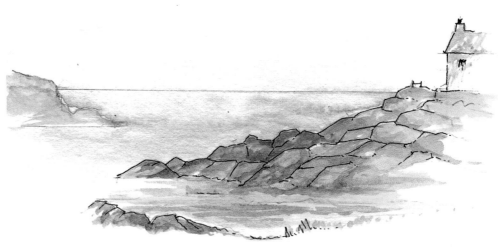

Right: The sketch and those on the following pages show where colour is the main attraction and a small amount of pen work is added to give form and texture. The various colours of the rocks in this coastal scene just need the addition of a few pen lines to explain form.

Right: I made this drawing quite carefully from a photo having visited the area before. I concentrated on the shapes of the buildings and their detailed patterns of materials, added a few points of colour and washed in the trees in the background.

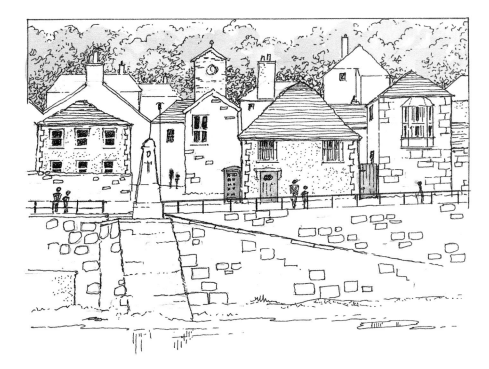

Below: This cottage attracts attention because of its red colour-washed walls, seen against white-painted woodwork, white colour-washed stone garden walls and grey slurried roof. The darker pen an ink shadows help to show the form of the entrance.

Another time, you might be attracted by a field of bright colour, such as the yellow of oil-seed rape. In this instance, first make a very simple sketch in pen and ink. Then, dip a large brush into a well of bright yellow watercolour and sweep it across your picture. As with the sketch on page 66, do not bother about keeping it within the exact confines of the field but go right across the paper.

Combining pen and watercolour

There are several ways of combining pen and ink and watercolour in a picture, and I have described some of these as follows.

● Where colour, including local colour, is the more important and only indications of line and texture are added in pen and ink. Local colour is that which you see, for example, in the materials of a building or in the poppies in a field or in a painted door. It is the colour of the subject itself without being affected by light or shade.

● Where line and texture are the more important and colour is only indicated when it is necessary in order to add interest.

● Where pen and ink are important to show lines and textures, and monochrome washes are used to indicate tones. These washes can also pick out subsidiary shapes, such as building stones, trees and other foliage.

Coloured pencils

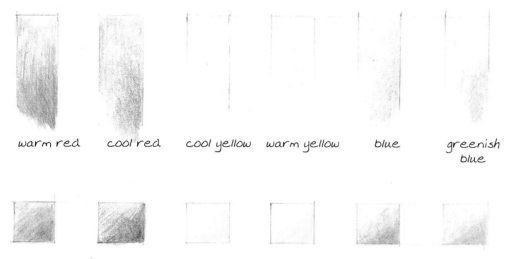

warm red cool red cool yellow warm yellow blue greenish
blue

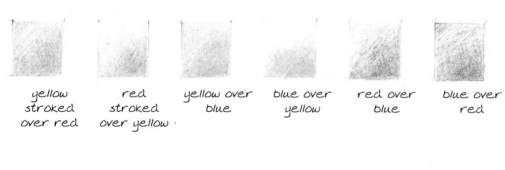

All these blend to cross-hatching for darker hues in the corners

yellow red yellow over blue over red over blue over
stroked stroked blue yellow blue red
over red over yellow

Effects of using coloured pencils

Water-soluble pencils with water added

If you are using black ink, varying grey washes will be suitable. However, also try using sepia ink with brown washes.

In all of these approaches, shadows might play a large or small part. Whether you show them in pen or in wash rather depends on the balance of your whole picture. If you have used colour as the main interest in your image, shadows in pen might detract from it. On the other hand, if penwork forms the main part, washes for shadows might appear weak. Much depends on the distribution, size and intensity of the shadows.

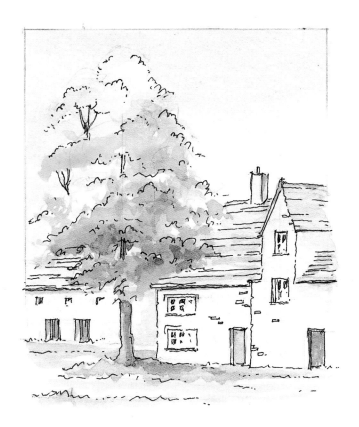

You might like to think about the colour of your paper and ink in relation to your subject, and you could use one from the tinted range of watercolour papers now available. For example, old buildings can look very attractive when drawn in brown ink on cream-coloured paper. Alternatively, you could use grey ink on bright white paper to emphasize a cool landscape. However, some coloured inks tend to fade in time, so it would be better to use liquid acrylic.

Left: This sketch emphasizes the autumn colour of the tree seen against the pale creamy-gold colour of the houses which are built with the local stone.

Right: This is taken from a sketch which I made some years ago, when one of the ideas of that time was to apply different colours to houses in a terrace. I imagine that these will now have been painted pale cream in keeping with the original style of these Georgian houses.

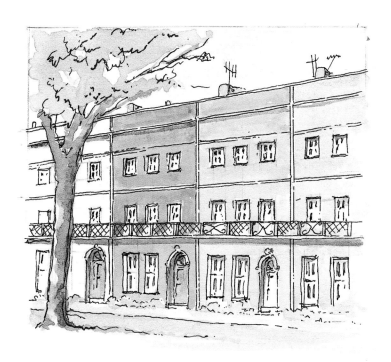

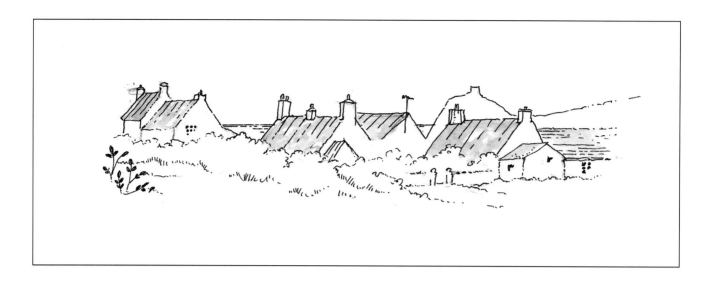

This page: I made these sketches because I was attracted by the shapes and patterns of the buildings in their immediate surroundings. I added a little colour afterwards to give added interest. (I emphasized the decorative qualities of the plants because I thought that this made them more interesting at this small scale.)

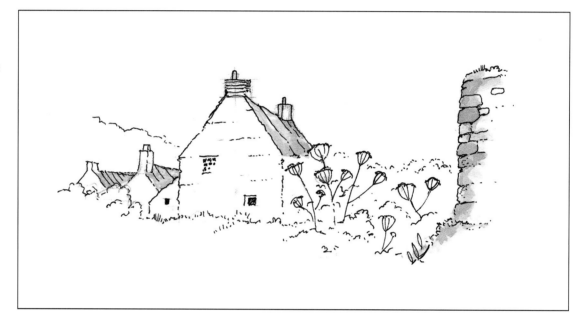

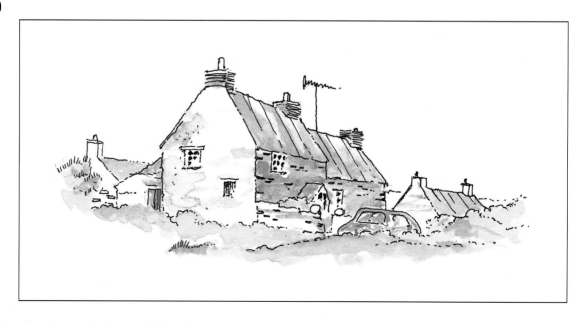

Sketching Landscapes in Pen and Pencil

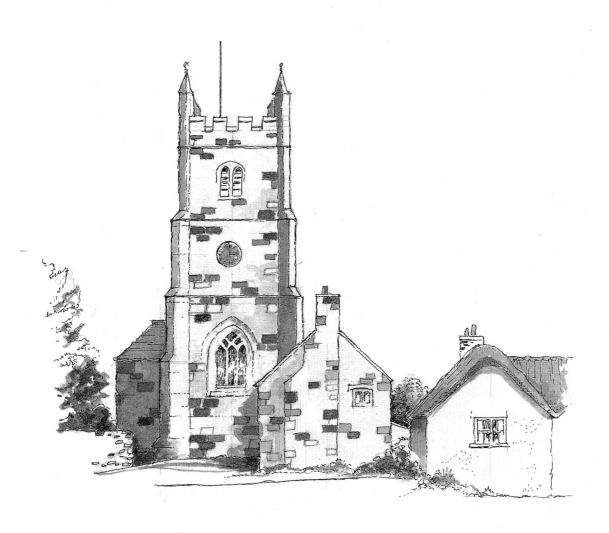

Above: This picture shows monochrome washes added to a pen drawing. I have used diluted acrylic for the washes because when an acrylic wash is dry you are able to add further layers of colour over it without disturbing the one(s) underneath.

Using photographs

6 Using photographs

When the word 'camera' is used in connection with drawing and painting, some people think that the use of photographs seems to indicate that the artist does not have the talent to tackle making a picture without some mechanical assistance. This is a misconception. It is not the tool itself that is important; it is what you develop from using it.

As far back as the early fifteenth century, some artists were using lenses and mirrors to reflect images onto a canvas. They then followed the outlines with a brush or charcoal to work up various compositions and assist them in producing very detailed paintings. Such methods did not detract from the beauty and integrity of these paintings.

Occasions for using a camera

The camera is a useful tool in recording instances of time such as cloud formations, moving water (including wave patterns) and fleeting conditions of light. I have found it equally helpful in recording small boats in a harbour, which have a habit of being rowed away out of a work in progress before you have drawn them in. It is also useful in making a record of a complicated subject when your own time is limited.

Choosing a camera

The photograph resulting from looking at a subject and clicking the shutter, often does not look like the image which our eyes and brain registered. This is because the type of camera and lens used affects the finished result, together with outside influences such as the changing light and methods of processing the film. Many people these days use small 35mm cameras with fixed-focus lenses. They are useful for recording wide aspects of scenery, but distant objects such as buildings or mountains can be much smaller and flatter on the print than they appeared to your eye.

You can overcome this problem by using the zoom-lens facility if you have one, but making a quick sketch to record what you see will help you to interpret your photograph more accurately. A single-lens reflex (SLR)

Photographing buildings

When you record a tall building, the resulting photograph will show sloping (or converging) verticals unless you stand well back from the subject. If you are using an SLR, you will see the effects of this in your viewfinder. You can correct the distortion in your drawing, unless you wish to depict a dramatic effect emphasizing position or height. Remember that any decoration on the upper part of the building will also be distorted.

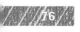

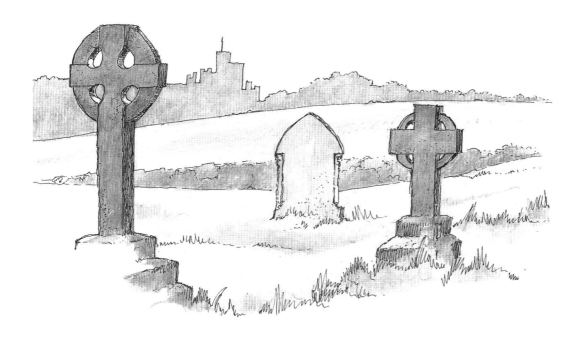

The purpose of this page is to show how a photograph taken with a small 35mm camera with a fixed-focus lens (usually wide angle) can apparently alter physical distances. The castellated building in the distance appears in a different relationship to the tombstone in the foreground than that registered by my brain while I was sketching. The photograph indicates that the building is much further away.

In my sketch I have altered the position of some stones and left others out in order to make what I consider to be a more uncluttered composition. The subject was back-lit and the distribution of tones is important in the composition: the lighting, in fact, was rather flat so I increased the tonal contrast and used a water-soluble graphic pencil to indicate the variations.

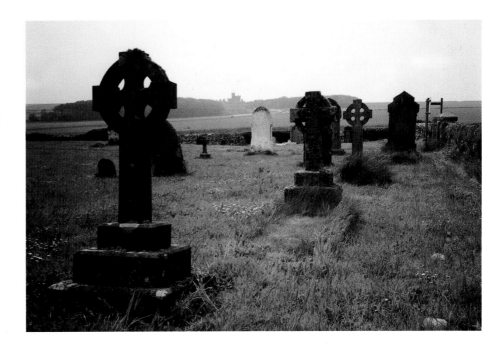

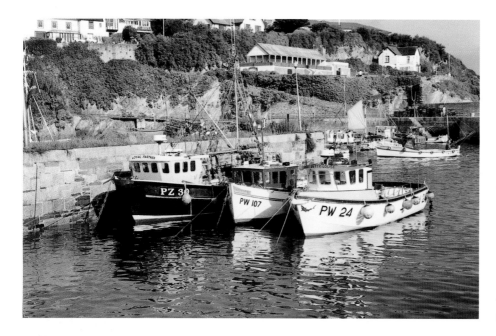

Left and below: This shows a colour photograph and its conversion to a grey tonal range. This is a useful exercise in learning how to gauge a scene's tones.

Improving tonal interpretation

Your tonal interpretation of colour can be improved by taking a colour photograph and having it converted to a black-and-white image. It is important to choose a photograph that has a good, even range of colours and no large areas of black shadows. If you have a computer, you can do this yourself. If not, take your photograph to a processing shop and ask them to print it in monochrome. You can now compare this copy with your original coloured print. (For more details on tone, see page 57.)

I took this colour photograph on a day in early autumn just as a record of a pleasant time. The main interest of the scene lies in its colour, with the blues of the sea and sky and the brown of the beach and headland.

Converted to tones of grey, it is not so appealing: the tonal range is rather flat. The lightest tone is that of the white paper representing foam on the waves. The darkest tone is the dark grey-coloured part of the cliff face. There are only about four tones in the picture, but this is fine for interpreting in ink for a black-and-white drawing at this small size.

For my interpretation of this photograph I have slightly altered the composition. I have shown more sky so as to give an open feeling to my picture and shown less of the beach because the details are rather repetitive, although I have emphasized a little of its surface to give interest. I have also added some tone to indicate a few clouds.

In a scene like this you need to balance the areas of tone so that the main ones are not lost. In this scene the main ones are the dark areas of the cliff face and their reflections in the damp sand and the dark of the sea in the far distance. I have not put an overall tone on the beach but used the white of the paper to give a background to indications of the pebbles.

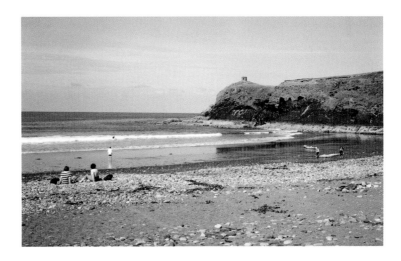

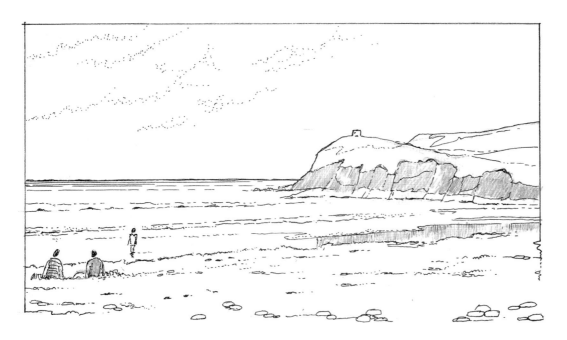

Panoramic views

If you wish to draw a panoramic view, and time or lighting does not allow you to draw this in detail, make a quick sketch showing salient points of the scene, and take two or three photographs, panning the camera to include the scope of the scene. Stand in the same place so that your eye level is constant, and make sure that you overlap each image. When you take the photographs, make a note of the direction of the light.

camera with changeable lenses can give more accurate results. However, this equipment is much heavier and more expensive than a smaller 'pocket' camera, and, as long as you realize the points to be considered when looking at photographs taken, all will be well.

Bear in mind that if you are taking a photograph of a room or other area where objects are near, those closer to you can appear distorted. For example, a square table can look oblong or a distant wall can appear further away so that the room looks bigger than it is.

Collecting photographs

Use your camera even when you are not on a sketching expedition. Any trip provides an opportunity to compile records of images that you can refer to for information at a future time. You can make a photographic collection of anything that interests you: cloud formations, sea patterns, details of buildings, close-ups of plants, and so on.

Keep a notebook with your camera and note down the time of day and the season when you took the photograph and, if possible, the direction of the light. These notes will be important when you wish to make your sketch in the future, when you might have forgotten important factors that may not be clear from the photograph itself.

You might wish to draw a picture of a place, and the only record you have is a photograph taken some time ago. A photograph, whether monochrome or in colour, will show many gradations of tone. To reduce these and give enough impact to your drawing, pick out the darkest and lightest areas in your photograph, and pick out three tones in between.

Right: I was given this photograph and asked to make a sketch from it for the cover of this book. One problem with photographs, from a sketcher's perspective, is that they often contain shadows of equally dark density, overriding any illusion of distance. And yet, in reality landscapes possess recessions that you can appreciate when you actually sit in front of them. The view as shown in this photograph is attractive in itself, but needs some artistic treatment to make a pleasing sketch.

Fortunately, not only was I familiar with an area similar to that shown, I was also able to base my interpretation on the points covered in this book. For example, when considering the composition, I decided to omit some of the very dark trees on the left in order to give more emphasis to the mountain. It was also important to use perspective to show recession in parts of the scene where it had not previously been visible due to the back-lighting.

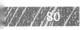

Looking at scenery

50 b

Edge of page ↓

Mountains

7 Looking at scenery

People can say of a specific place or region that the scenery is lovely, perhaps meaning that it is awe-inspiring or calming, rugged or gentle. They are usually talking about the basic physical qualities that have shaped the area. Over the centuries, these qualities may have been altered by people, to give the appearance of what we call 'scenery'.

Geological and human influences

The basic physical qualities of scenery lie in its geological formations. Where rocks have been bent and broken in the processes of folding and faulting, the resulting scenery is dramatic. In contrast, where rivers have altered their courses and created flood plains, the scenery is gentler. Rocks may have been altered by changes deep down in the earth itself. Some granites have been changed into beautiful rocks with different bands of colours, clay (which in geological terms is a rock) has been compressed into slate, and some limestones have been changed into marbles.

Other elements of change that have contributed to different forms of scenery include wind and water erosion, rivers carrying rocks and boulders down from higher ground levels, and gravity, which has exerted a force resulting in landslides.

In recent times (in terms of the geological timescale), agriculture has played a large part in the appearance of the land. During the last three or four hundred years, the appearance of some areas has also been radically changed by industrial works including

mining, quarrying and other mineral extractions. Coal mining results in large coal tips, and stone quarrying creates deep holes and artificially formed cliffs. In a few granite areas that contain certain mineral lodes, these have been altered by underground gases and water action to form kaolin, the popular name for which is china clay. The industrial processing of the china clay results in the huge, conical waste tips of silica, which gleam in the sun and dominate the scene from miles away.

Composing scenic views
The term 'scenery' is usually descriptive of distant views. When sketching these, you need to remember to include something in the foreground and middle distance to indicate the scale of your picture. This could be a nearby fence or wall, and a distant single house or group of farm buildings.

Some gravels are also made from industrial extraction processes. The gravel itself forms small conical tips, and the pools and lakes left by the process have, in some cases, been used for the introduction and protection of birds and other wildlife.

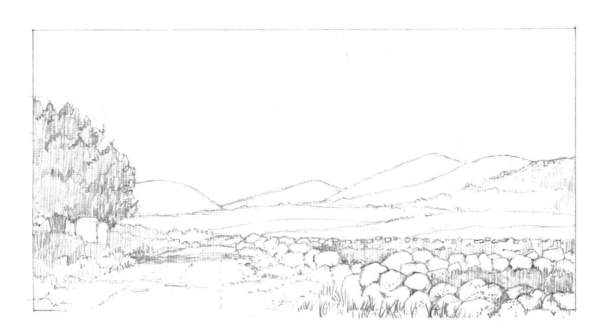

Above: In this sketch, the far-off, small mountains have been drawn in outline. This simple treatment gives a depth to the picture because the rest of it is shown in more detail, the foreground especially being emphasized.

Travel considerations

We are fortunate if we are able to enjoy looking at scenery. Often when we look at the view we are also physically affected by other influences, such as the weather (are you hot or cold?), the time of day (are you hungry?) and the season (is the light fading too quickly for you to draw?). When you travel farther afield, these considerations can become even more important.

Choosing what to convey

As artists, we can only translate part of our surroundings on to a relatively small sheet of paper with, in our case, the simple instruments of pen or pencil. Of course, what we wish to select from our surroundings applies to any subject that we think of drawing, but the choice from the wide aspects of scenery can be more difficult to encompass on a sheet from a sketchbook, compared with a village street or a building.

Because scenery is so varied throughout the world, it follows that its various aspects can best be described by using different materials.

The two sketches below show how directional light can bring out the shapes and forms of hills. You can also note the size of the hills relative to the buildings in the scenes, and how the foreground in each sketch indicates the different distances from the viewer. For the purpose of these two examples, I have taken the broad outline of each sketch from photographs. If you find scenes when the direction of the light is particularly attractive, it will be helpful if you take photographs so as to capture its fleeting effects. Select the main shadows which give form to the hills in your picture; do not be tempted to try and show many tones.

Below: I have drawn this scene with an HB pencil, using various techniques to emphasize form. The foreground trees are in simple outline to form an irregular frame for the picture while concentrating the eye on the hills in the middle and far distance.

Bottom: The detailed foreground leads the eye gradually to the hills. I used technical pens of varying widths to give an illusion of distance.

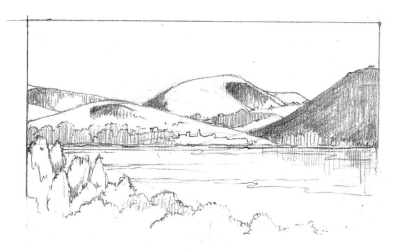

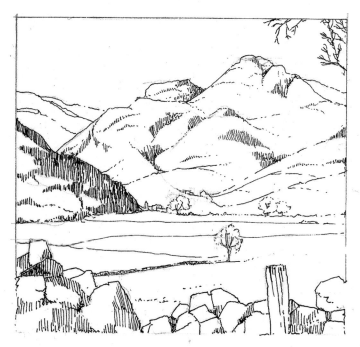

I have mentioned before the convenience of carrying just pens and pencils with your sketchbook, and these materials are particularly suitable for depicting a wide range of scenery, including the linear attractions of mountains and hills, rocks and cliffs, and the patterns of fields divided by hedges or walls. I have illustrated and described the drawing of these in this chapter, and because parts of this book interact one with another, some additional sketches of scenery appear on other pages.

Not all types of scenery are easily accessible for the artist. Some are too difficult to walk in or near, and some are too isolated for anyone without private transport. However, comfortable and safe viewpoints can enable you to see distant patterns and to appreciate atmosphere, which you can translate into unusual or abstract sketches.

Mountains and hills

Mountain ranges vary enormously in their size throughout the world. For example, those in Great Britain are dwarfed by others in Europe and Asia. Some mountains are so well known, either in their own country or by the world at large, that pictures of scenes including them will be instantly recognizable, so it is important to be very accurate when you draw their outlines. In a sketch, the grander ranges will usually make a distant backdrop for your picture.

Even more easily accessible hill country may have some areas of difficult terrain, and you may want to use your camera for recording your journeys. However, the actual experience of being in such places will add to the interpretation of your photos later on. Sometimes you will be able to settle in attractive places catering for visitors and central to mountain and hill country.

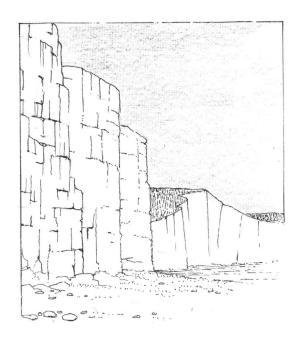

These two sketches show just two examples of how sea cliffs can differ in appearance according to their geological formations. The top sketch shows chalk cliffs with a sheer face and the lower sketch shows the sculptured, rugged forms of granite. The chalk shows patterns of horizontal bedding and vertical plane lines, while the granite has vertical planes and weathered, sculptured surfaces.

Left: I have drawn this with a fine technical pen, picking out some of the horizontal and vertical lines in the foreground cliffs. I have used an HB pencil to put a tone over the sky to show up the contrast with the dazzling white of the chalk.

Below: I drew this, again using a fine technical pen, with a little shading to emphasize the divisional sculptured quality of part of the cliff. The tonal values here are very similar to each other. (The tonal values alter when the setting sun lights up the cliff face.)

Cliffs and uplands

Cliffs can be by the sea or in inland ravines and gorges. Cliffs by the sea are usually accessible from the beach or by safe public footpaths. Cliffs defining ravines or gorges vary so much in height and grandeur that much will depend on their suitability for depicting their scale in a sketch. Edward Lear, the writer and artist, made some evocative drawings of dramatic cliff scenery on his travels in Europe. He travelled with a companion and found good vantage points from which to draw. They travelled on horseback or by horse and carriage on difficult roads and paths, but in those days it was quieter and easier to set up his drawing equipment. Some of his drawings were later made into lithographs to illustrate journals that he wrote and published about his travels.

Uplands include stretches of moorland, some divided by stone walls and others where heather or gorse predominate. The open character of

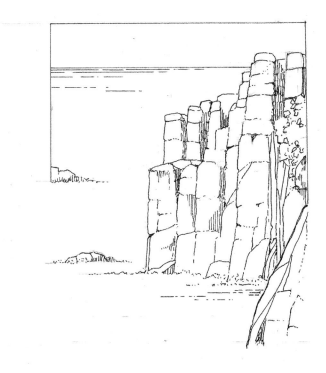

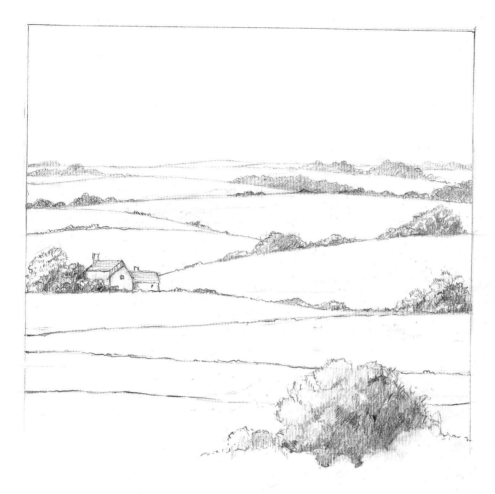

Left: The purpose of this sketch is to show how to convey the qualities of rolling, cultivated countryside divided into fields by hedges and trees. The variations in the soft downland countryside – as differing from the harsher qualities of the stone uplands – can be achieved by using the softer gradations of tone possible with pencils. Here, I have used an HB pencil, lightly for lines in the far distance and with more detail and shading in the trees and hedges as they approach the foreground.

It is helpful to organize any composition so that light areas are placed against dark ones and dark against light, and here it is comparitively easy to alter the positions of trees and hedges to achieve this.

With all open scenery it is necessary to include something to give scale. In this case, the little house on the left and the foilage in the foreground help to show this.

uplands makes it easier to find suitable sketching places, but, as always, you need to ensure that you will not cause problems for farmers and landowners. Local residents might be able to tell you where suitable viewpoints are.

Downland

The word 'downland' is descriptive of gently rolling countryside with hedges dividing cultivated fields and with sheep grazing the upper slopes.

Extractive industries

These hills, although artificially made, form shapes which make an impact on the wider countryside scene.

Facing page: Stone country is very suitable for drawing in pen and ink. I have visited both of these areas and my sketches are based on photographic illustrations.

Top: This is a moorland area in the south of England. It is rugged but the lower slopes are wooded. The stones are granite which has weathered over millions of years to form rocky outcrops and to split into distinct blocks. Again, the perspective is indicated by different line thicknesses and the lines of splitting are shown by shading the joints, similar to those in the granite sea cliffs shown previously. Scale is given by the rambler perched in top of the rocky outcrop.

Bottom: This sketch shows an area of upland in the north of England. It is used for grazing sheep and is divided up by dry-stone walls about 5ft (1.5m) high. The appearance of the walls varies according to the local stones from which they are built. The perspective of this scene needs to be shown by varying the thicknesses of line you use; thin in the far distance and thicker in the foreground. Scale and distance have been indicated by the lone shepherd making his way up the moor. Because one of the main attractions of the scene lies in the contrast of the white limestone walls against the grass and heather, you should use pencil, crayon or a wash to give a tone to enhance this.

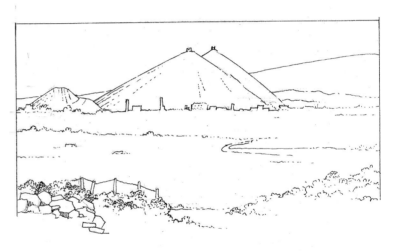

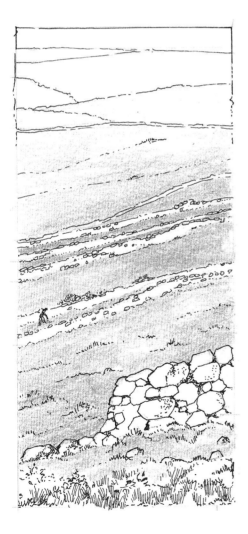

Above: The two drawings shown above were made after visits to very different places and at different times. They illustrate how the processes of two particular extractive industries have had an impact on the surrounding countryside. They also show how perspective and scale affects distances when you draw similar shapes in different views.

The top sketch shows gravel extraction, and the bottom one shows the waste mounds of silica arising from the extraction of china clay.

Although in the sketches the mounds are shown about the same size, their distance from you, the viewer, is apparent when you look at the intervening spaces with the machinery, fences and vegetation. Then you will appreciate that the actual mounds of silica waste are very much larger and higher than the mounds of gravel.

You might wish to add some notes on colour and tone, especially to show the white mounds of silica against the darker tone of the sky.

Looking at townscapes

8 Looking at townscapes

To give the word 'townscape' its basic and rather dull meaning, it covers the appearance of urban and rural developments. These may be old or new, or a mixture of both. The word itself does nothing to conjure up the exciting and often vibrant environmental and social aspects of towns, villages and cities that give them their character. It is this which we, as artists, wish to capture and depict.

The character of a single building is formed by its appearance, both outside and inside, and this is influenced by both its situation and its development through the ages. This would have included such matters as improved transport in conveying both people and building materials, and different uses of the building by different types of people. So, if one building can possess a complex character, it follows that a whole street or town could be quite complicated to draw, especially if it has come into being over a number of years.

Planning ahead

If you intend to visit a new location, you will not know whether you are going to sketch its relationship with the surrounding area, or whether you will find little corners to explore. To save time, consult a map before you set out, so that you can see if there are any steep hills that might hinder your progress. You can then adjust your sketching time to cope with this situation. This is especially important if you need to rely on public transport when making your journeys.

Towns and villages in their settings

The locations of towns and villages in the wider setting of country or seaside often raise interesting considerations of composition and perspective. You could sit at the head of a valley leading down to the sea and have a view of rooftop textures. Alternatively, you could sit at the bottom, looking across to the shapes of the fronts of buildings, with little additional shapes of windows, doors and chimney stacks (see overleaf).

Villages can nestle in a valley below rising hills, and in these cases it will be important for you to consider the boundaries defining the fields that sweep down to the lower parts of the valley.

Little clusters of houses, perhaps with a church, can easily be seen across flat country, and as a result their outlines can be interesting to draw. You can define and emphasize the foreground with additional detail. Small fishing villages, with their different sizes of houses and boats, present a wide choice when it comes to selecting parts to sketch.

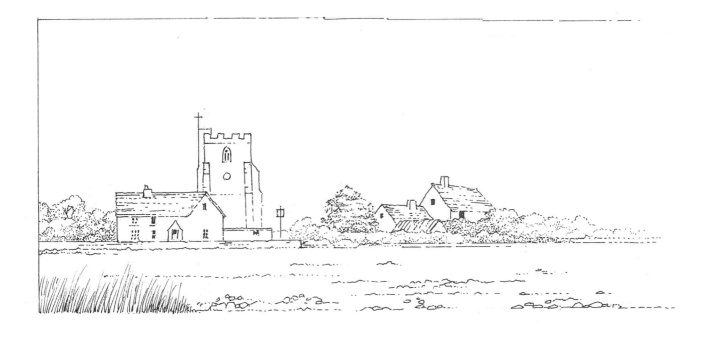

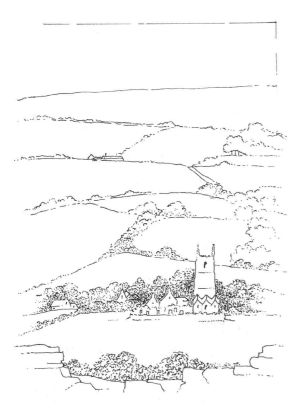

These sketches show English churches, but any small group of buildings could be included to give a vertical point of interest in similar situations. You might, perhaps, have a windmill on your skyline or an agricultural silo in the valley.

Above: The horizontal composition of the village on the skyline gives a feeling of open and extending countryside.

Left: This sketch of the church in the valley has been made from a high vantage point. The upright format of the picture emphasizes the depth of this particular valley. The foreground rocks are firmly drawn, while the distant church and churchyard are drawn only in outline, against the background of lightly textured trees and bushes. Broken outlines and dots indicate trees and bushes further away, and the tree line leading onto the bare moor is just faintly outlined.

Looking at townscapes

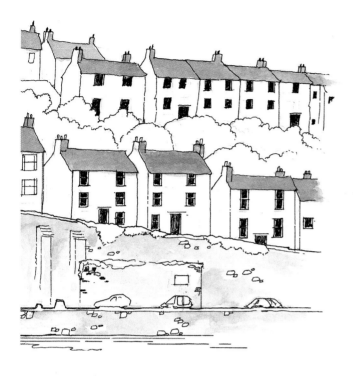

Left: Buildings on a hillside are appealing by reason of the shapes and sizes of their walls, apparently piled up one on the other.

They can be viewed as here looking across a harbour or up the sides of an inland valley. Because the interest here is in all the different shapes, one way in which you could draw your picture is with simple outlines emphasizing the window openings and chimney stacks and to a lesser extent the roofs, all with plain tones.

Again there are many ways in which you can take advantage of the way in which these little houses are situated.

Right: The patterns made by the different shapes and textures of rooftops when you look down on them make interesting subjects to look at and draw. I made this sketch to show you how to emphasize this interest and to make an interesting and slightly unusual picture from it.

Any picture you make from a high vantage point can have this appeal, whether the roofs are all alike or have different textures. You can treat this subject in different ways; you can define the main outlines, including the roofs, with a thin line and put a tone with pencil or a wash on the roofs themselves or, as I have done here, draw the main outlines in ink but exclude the roofs, defining them with direction lines to indicate the actual roofing material (these are tiles).

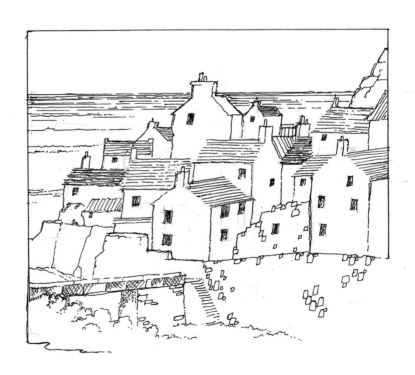

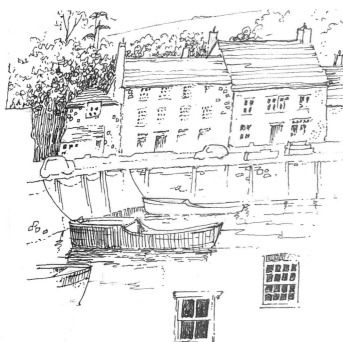

Left and below: I made these three sketches originally some years ago and I have redrawn them to indicate a little of the character of this small Cornish fishing village.

At the time, I made a lot of notes regarding the building materials, for example, local stone and slate, and details of windows and doors for future reference. I also noted colours: red bricks, grey slate roofs, and so on.

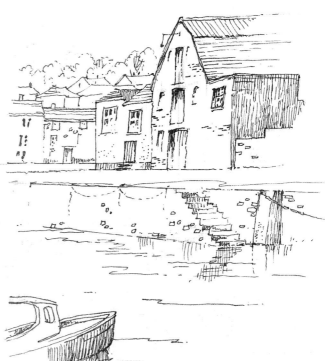

Left: I drew this from an upstairs window to show details of the old roofs and walls with their slates, brick chimneys and the foreground telegraph pole.

When I returned some years later some of the buildings had been altered, including some to provide more living accommodation.

Right: When I saw this corner of a village the afternoon sun was fairly low in the sky and the light was still quite bright. The house facing you is partly built of old dark reddish-coloured stone (the upper storey has been given a coat of cement) and was in shadow but was lighter in tone than the dark foliage of the tree behind. The right-hand building received full sun and was very light in tone so I treated it as white in the tonal scale, the darkest tone being that of the tree. In a small sketch like this, an attempt to ink in the midtone on the facing house proved to be difficult without detracting from its importance in the composition, so I took an HB pencil and added a tone with that.

Below right: This scene is made to give an idea of choosing a view through an open foreground structure. The shadows here and the firmer outlines of the open market cross make a good frame for the distant view, which is drawn with a finer line.

Cities

When sketching cities, cathedrals make interesting subjects. However, in well-known places where there are likely to be lots of visitors, it is not easy to find a quiet place to sketch the view you want to depict, so you could take a photo for future reference. If you want to include the cathedral itself, and this is what usually gives that type of city its character, it is better to go a little further afield and sketch it in the near distance.

Shops

Small shops in a town or village, where they display their wares outside, provide really interesting subjects. You should treat the shop front itself quite simply, and the goods for sale outside with detail. Depending on what

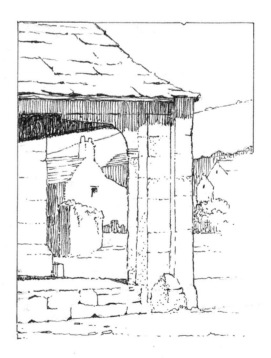

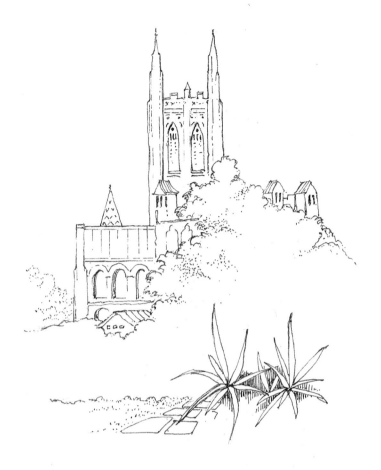

Above: I found a secluded part of the cathedral grounds to make this sketch, where it was quiet and peaceful with plants and seats. It was necessary to include some plants in the foreground and bushes in the middle distance to give scale and depth to the picture.

This open situation, as differing from the enclosed vista shown left, called for the scene to flow out into the surrounding space. Both types of scene could be applied to a small church in a town or village.

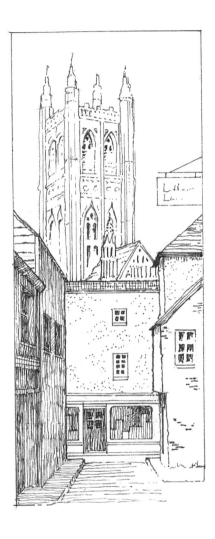

Above: This drawing shows how a cathedral or large church can dominate a street scene, making a pleasing composition. At the time I was there this corner of the city was very busy (it always is busy!) so I decided to take some photos for reference. Later I found a very old photographic illustration and made this drawing using part of it together with my own notes and photos. I decided to treat the scene as it could have looked in years gone by, with no people or vehicles in sight and I drew a firm enclosing line around most of my drawing.

the goods are, their attraction for drawing needs to be considered. Flowers and fruits are soft in character and their main attraction lies in their colours. Household goods, including buckets, boxes, steps and planks, have interesting, firm shapes that cast good shadows. These are very suitable for pens and pencils. Of course, you could add a splash of colour if you so wish.

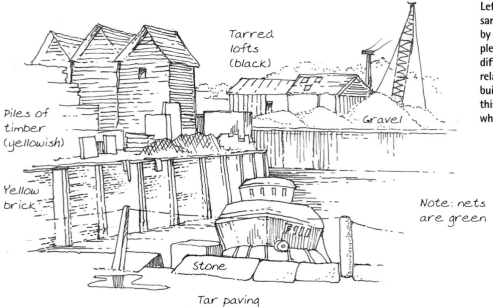

Piles of
timber
(yellowish)

Yellow
brick

Tarred
lofts
(black)

Gravel

Stone

Tar paving

Note: nets
are green

Left: This is another sketch of the
same little harbour which is used
by local fishermen and by small
pleasure boats. There are several
different vanishing points here,
relating to the boats, some
buildings and the quayside. I drew
this from the shelter of a shed
while it was raining.

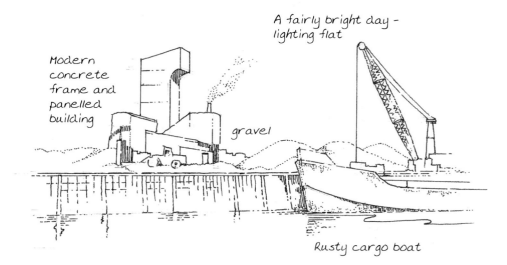

Right: A sketch of a small harbour
which deals with conveying locally
extracted gravel to inland sites
for distribution.

Modern
concrete
frame and
panelled
building

gravel

A fairly bright day -
lighting flat

Rusty cargo boat

Note: Harbour walls on
this side constructed
of baulks of timber

Local industry

However dramatic a heavy-industry scene can
be to draw, it is not usually possible to get in
to see industry at work in factories or on
large sites without permission. Working
museums, both inside and out of doors, are a
possible source of information for sketching

old industrial machinery. However, small-
scale industrial work can be seen in many
places, including small harbours. These can
be comparatively easy to sketch and
photograph from quaysides and sheds, as
shown in the sketches above.

Above: Shops that cater for visitors on holiday sell items like patterned buckets, spades, beach balls and colourful hats, all of which have definite shapes and give you an opportunity to use coloured pencils, brush pens or coloured fibre-tips.

The coloured hats attracted me on the outside of this little shop in a seaside town and I quickly took a photo; the little lane was quite congested with summer visitors. The shop is an old house with uneven rubble stone walls washed over with white. I have indicated the uneven quality of the walls with random areas of dots. I have also simplified the contents of the window so as not to detract from the coloured hats. A few pen marks indicate the material from which they are woven and I have used watercolour for their main interest.

Sketching from windows

You might be able to sketch large, popular buildings or areas from a window. Sketching any city or town from a window has several advantages: you can sketch a wide view of a varied skyline and work down to foreground interests, you are not likely to be jostled – however unintentionally – and you can be sheltered from bad weather.

Above: I drew this scene while sitting at an angle to the whole window. The casement itself was open in such a position that it conveniently framed the distant cathedral. I drew this sketch in a decorative way using firm ink lines of differing widths and random marks for the foliage.

Small corners

When you have looked at the possibilities of sketching the town or village in its wider setting, you might like to explore it in more detail. Its buildings and lanes should make interesting subjects and you might come across unexpected small corners, brightened with flowers in pots and decorative containers. Or you could find a small yard with garden implements or old household objects in it, enclosed by a low stone or brick wall or wooden fence. All of these different textures and shapes can be good to draw.

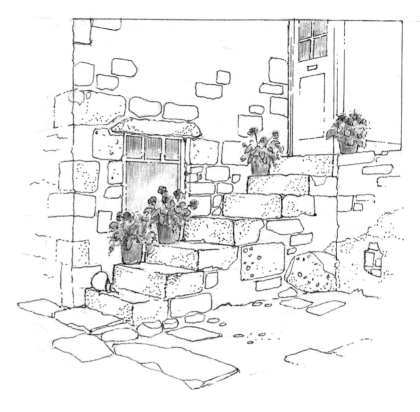

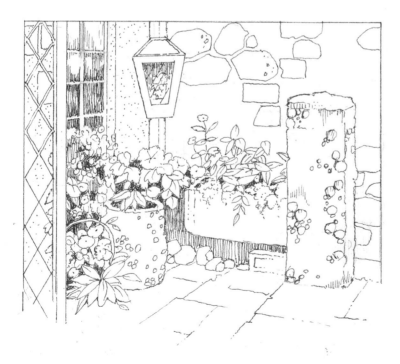

These two pictures show corners of a small fishing village and are based on sketches and notes that I made at the time, together with some photos that I took myself.

Above: In this sketch I concentrated on line, texture and pattern, and added a little colour to the plants and flowers with coloured pencil.

Left: I also concentrated on line texture and pattern in this sketch, but added shadows to emphasize the various forms, including the plants.

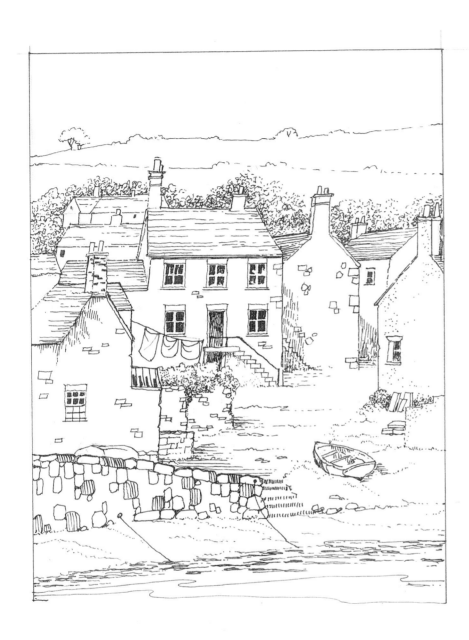

Above: This drawing concentrates on the shapes of buildings and their materials contrasting with natural elements of sand, water and foliage. It is based on a sketch I made sitting with a group of like-minded friends on a warm sunny day, when the summer visitors had departed from this little fishing village.

I was perched on my stool, sitting on a branch of the harbour wall just opposite the view I was sketching. You will see that the water level in the harbour was quite low, but sufficiently deep to allow the owners of some small rowing boats to move about.

I made the original sketch using a technical pen with an integral ink cartridge for its supply. These pens need an occasional shake to encourage the ink to flow, and thereby hangs a tale! I gave the pen an encouraging shake, rather too vigorously and it flew out of my hand into the water far below, where due to the balance of the pen it floated upright quite out of reach even from the harbour steps.

I ran around to the quayside hoping to find some little shop selling seaside goods which might have a net on a pole like the ones children use for exploring rock pools for shells and stones, but it was the end of the season and the shops were shut. I wandered back and found that my friends had persuaded an elderly fisherman to row over in his little boat and rescue my pen, and one of my friends clambered down the slippery slope and took it from him. The moral here is: never shake your pen in the direction of water!

Buildings

9 Buildings

Being a retired conservation architect, I cannot see an old building without wondering who built it, when and why. I look at the materials of which it is built and wonder where they came from, and my fingers itch to record old buildings and sketch or photograph their form and texture. Fortunately, pen and ink and pencil are ideal for depicting the irregularities of naturally derived building materials.

While it is not necessary to know the full history of a building in order to make a good sketch, the observation needed to draw it can arouse a wider interest in, and appreciation of, your subject. Although my drawings are based on my own observations, the techniques can be used to depict buildings anywhere.

In the section on perspective (see page 48) we looked at how the drawn appearance of buildings is affected by eye levels and vanishing points. This sketch takes this a step further by drawing guidelines to indicate the main sections of this small house, which is standing at an angle and on flat ground.

First find a comfortable place to sit. Sketch in your eye level according to your sitting position. Draw in the left-hand edge of the front wall, assessing its extremities above and below your eye level. (The lower edge can be assessed by looking at where the wall meets the ground.)

By following the procedure that I described in the section on perspective, and by careful observation, sketch in the line of the roof at an angle where it will eventually meet the line of your eye level. Do the same with the line of the bottom of the wall.

To find the width of the front wall, see how it relates in size to its left-hand edge. (In this case it measures about one and one-third of the height of the left-hand edge.) Find the angle of the line to the vanishing point of the gable wall at eaves level. Assess the width of the gable wall at eaves level in relation to the front wall.

You should now be able to sketch in the position of the windows, doors and ridge-line, remembering that windowsills and heads, the door head and ridge-line all follow the lines to the main vanishing point on the right.

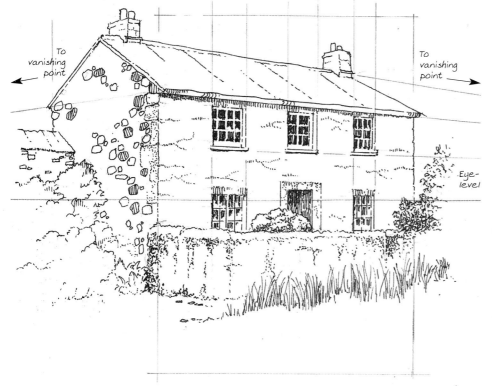

To vanishing point

To vanishing point

Eye-level

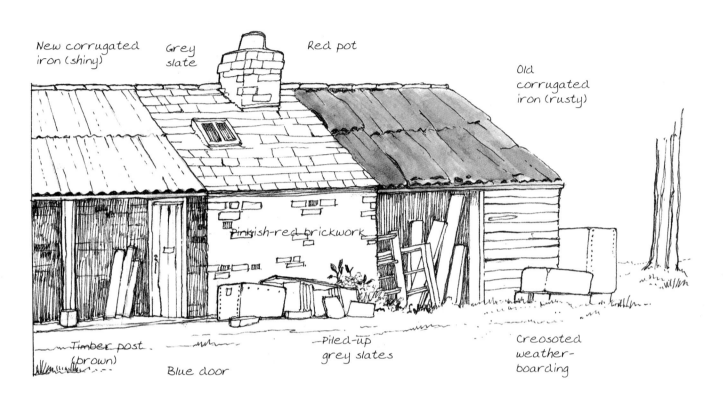

New corrugated iron (shiny)

Grey slate

Red pot

Old corrugated iron (rusty)

Pinkish-red brickwork

Timber post (brown)

Blue door

Piled-up grey slates

Creosoted weather-boarding

Above: Corrugated iron does not appear to be a very inspiring material, but it is sometimes used for roofing small sheds and you may want to include it in a sketch. In a black-and-white drawing its undulating surface can form interesting patterns, or rusty corrugated iron can help to make a splash of colour.

Choosing your approach

When you are sketching or developing your sketch later, you will need to bear in mind some practical hints that will enhance your picture. Old and weathered buildings should not have edges with firm straight lines; you should introduce a few slight irregularities. It is not necessary or advisable to draw every stone, brick or piece of wood. In fact, the incorporation of too much detail can

seriously detract from the appearance of your drawing, the purpose of which is to give an impression of that which attracted you.

This is not to make an excuse for leaving a lot out, but it is better to balance your areas of detail with plainer ones so that they will have more impact. Of course, the larger your drawing, the more intense detail it will bear, but the principle of balance will still apply.

A single old building, whether small or large, can make a good picture when its details are emphasized by careful attention to the effects of light. A picture composed of small images of several buildings will have its interest in the shapes of roofs, chimneys and walls. These could be outlined in pen or pencil with

simple shading to show their form, and adding simple blocks of colour might enhance such a drawing. Or, if the light is strong enough, the shadows themselves could give a dramatic effect.

Building materials

Where you have quite large areas of light or shade, include a few details of the building materials in order to break up these areas and add interest. When you are using lines to indicate shading, try to draw them in a way that shows form. For example, they can follow the lines of the grain of timber if it is fairly straight. If you have a stone sphere, you could use dots (stippling), intensifying them as the shadow grows deeper.

Buildings and their materials vary a great deal in the way they appear in different regions or countries. For example, limestones can vary in hardness, and this influences the shapes and sizes to which they can be cut at the quarry, which in turn affects the way in which the blocks appear in a building.

As an artist, your aim is to depict various buildings with their forms and textures in order to give a three-dimensional feel to them. The drawings shown in this chapter, with their descriptive captions and texts, should give you ideas of how to tackle your subject using different techniques with your pens and pencils.

Stone Some stones are dressed at the quarry and used for building a wall, and this can produce a regular pattern and a smooth surface. If it is very finely dressed and carefully laid, it is known as 'ashlar' work. Many small rural buildings were constructed from roughly dressed stone or waste material from local quarries, and these walls have a very textured appearance.

These sketches show various examples of stonework. They have been drawn with a fine technical pen, and also show different ways of indicating shadow. In the sketch right I have used vertical lines in ink to reflect the height of the recessed entrance. I have used pencil to show soft gradations of shadow in the niche, which is about 5ft (1.5m) high in the sketch below, and watercolour in the sketch on the bottom right.

Right: Irregular, roughly dressed external stonework.

Below: An external wall and niche built of dressed stone that has weathered over time.

Below right: A wall of flints, the edges and mouldings of dressed stone.

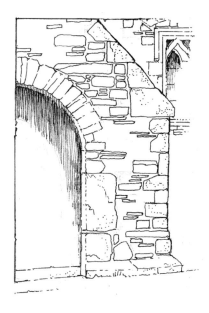

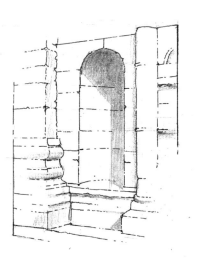

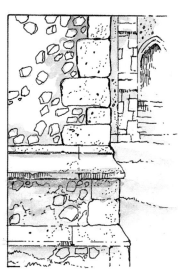

The colour of bricks

Bricks vary in colour according to the type of clay from which they are made and the temperature at which the raw clay bricks are fired. Some walls show patterns of coloured brickwork where the bond has been altered to make the pattern. In a monochrome sketch, you can shade the coloured bricks and thus reveal the pattern.

Thatch

This is a natural material obtained from low-lying reed beds or straw (generally from fields of wheat or rye). Thatched roofs have a chunky feel to them, and the manner in which the thatch is laid from eaves to ridge emphasizes its linear qualities. In some regions, thatchers incorporate intricate designs on the ridges, and these can be included in your sketch to show local characteristics.

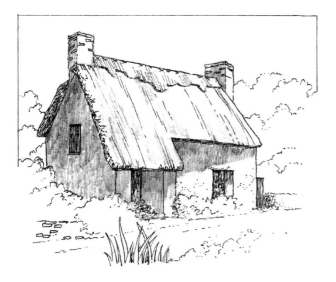

Above: This thatched cottage has plastered walls that have been washed with colour. The roof has been shown here with a few fine ink lines to indicate the direction and 'feel' of the thatch which incorporates a decorative ridge pattern. Because a large part of the cottage is in shadow it might have been confusing to indicate this with close pen and ink, so the shadows have been added in pencil.

Stones that can be quarried and dressed easily include limestone and some types of sandstone. (For example, Portland stone from England is a white limestone that was used for buildings and their features in London in the seventeenth century.) Granite is a very hard stone, and is difficult to work, but sometimes shows tiny pieces of quartz, which catch the light. It is quarried in large blocks and has been used in engineering works.

However, in the past, all types of stone were used in small buildings.

Some types of limestone and sandstone can easily be split into slabs at the quarry and these have been used for roofing. You will notice that these slabs are very thick in comparison to slates and clay tiles, and must be well supported. Where the supporting timber-roofing framework has not been strong enough, this usually distorts with the weight of the slabs and you might notice its effect for recording in your sketches.

Slate can be split into blocks or thin pieces. Blocks are called 'slate stone' and can be found in houses near the quarry and in other small buildings. When split finely and trimmed to various sizes, it was used to cover roofs in the region where it was originally quarried, and also for covering walls as additional protection from the weather. In the nineteenth century, when railway transport was readily available, roofing slate was carried to cities, towns and villages far away from where it was originally quarried.

Flints are taken from chalk or clay areas. Due to their uneven form, they cannot be used to make corners, so are used in round buildings or in conjunction with brick or stone.

Rounded beach pebbles were sometimes used in seaside places to make textured wall surfaces. These pebbles, with their shadows, make interesting patterns and you can include a little of these effects in a sketch.

Bricks and tiles Bricks have varied in size and finish, from being rough in the sixteenth century to more precise in the eighteenth and nineteenth centuries. Although laid in courses, early brickwork showed an irregular bond ('bond' is the name given to the manner in which bricks were laid in order to form a

Above: Detail of how a pantiled roof is laid. To create an overhang at the eaves, plain tiles were sometimes used.

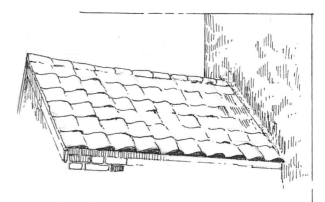

Above: A general view of a pantiled roof on an old courthouse, directly overhanging a brick wall.

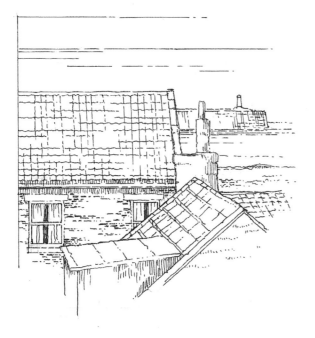

Above: Looking down on pantiled roofs where the chequerboard pattern which pantiles form is clearly seen.

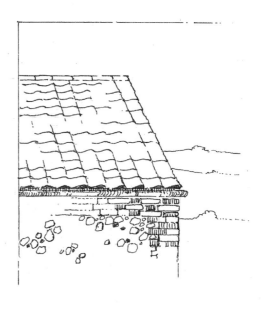

Above: A pantiled roof over a wall of uncut flints in conjunction with brickwork corners and banding.

thick, strong wall). Later on, more precise bonding was possible and this formed neater patterns on the wall surface. The bonds usually have the name of English, Flemish and stretcher. Look carefully at the bond patterns because an indication of them on your drawing, however slight this might be, can add interest to a sketch.

'Stretcher' bond just shows the sides of bricks, which are laid lengthways. This makes a wall of single thickness, but in past times a single skin of good-quality bricks was sometimes applied to a cheaper wall behind it. Stretcher bond is also used for paving or other decorative purposes where binding is not necessary.

Tiles are made from similar clay to that of bricks. Like bricks, they are moulded and vary widely in texture. Different forms include plain and ornamental tiles, and pantiles. Because they are moulded, the edges of tiles are of an even thickness (in contrast to those of quarried slates, which are uneven). Both plain and ornamental tiles are used in covering the surfaces of walls, when they are usually hung on a timber frame. However, the widest use for plain tiles is for roofing. Old roofs acquire irregularities due to the movement of the timbers beneath them and colour variations made by weathering.

Pantiles are clay tiles made with a unique S-shape in section. They make a very regular squared pattern on a roof. They originated in the Low Countries of Europe and were made in such a way that fewer were needed to cover a roof efficiently than plain tiles. (The word 'pantile' also describes a type of paving slab from the eighteenth century.)

Half timber This is the name given to a building where the members forming the structural timber frame are exposed, and the areas between them are filled with panels made from a form of plaster strengthened by twigs or slats of wood, or from bricks or stone fragments.

There are many types of half-timber construction, making different patterns in a building depending on its age and regional and local variations.

There was a time in the eighteenth and early nineteenth centuries when it was considered fashionable to build a skin of good-quality bricks over the front of a half-timbered house, because such houses were not thought to indicate good social status. This can be very confusing when one is trying to find a date for the original building.

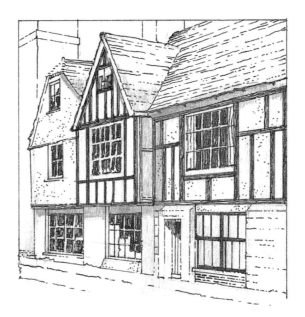

Above and below: These examples of half-timbering show just two of the many local and regional variations of this type of building. When half-timbered buildings are viewed from a distance, and depending on the size of your drawing, it is sometimes sufficient to show the timbers with a single line. I have lightly indicated in pencil the shading I feel necessary to give form and interest to the sketches. I felt that any additional ink work would detract from the constructions themselves.

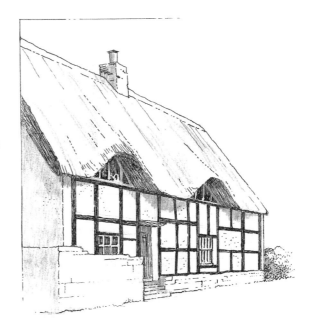

When you draw timbers in ink, do not fill in each one solidly: just leave some flecks of paper showing through, otherwise they can look as if the timber has been painted onto a wall surface. Remember as well that while in some regions the timber itself has been painted or tarred to give a black finish, the oak of which most houses were built has been left over the years to weather to a pleasing grey-brown colour, especially in Britain. This is easier to show on large-scale details.

Weatherboarding Known as 'clapboarding' in the USA, weatherboarding is a construction where boards are fixed to an underlying timber frame. In some areas, weatherboarding was made using oak or elm boards, which did not need additional protection against the weather. Softwoods such as fir and pine, on the other hand, need to be treated if they are to be used for weatherboarding, so when it became more widely available, it was painted or tarred. In England, this was usually done with white paint, and this tradition is still followed. However, some small buildings and farm and industrial sheds are still tarred.

In some parts of the USA clapboarding is sometimes painted with colours, and I have seen small houses in the coastal districts of Holland where green, white and black paint has been used. These colours look lovely

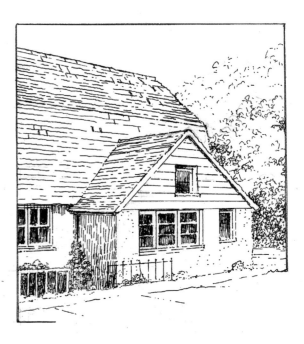

Above: Weatherboarding has been used here as cladding to the upper part of a later wing added to the house. The lower part has probably been built of brick and given a coat of cement. The main roof of the house has been covered with plain tiles and built with two slopes.

with the orange-red of the pantiled roofs, and if you are sketching there, you could add splashes of colour to your black-and-white drawing.

Weatherboarding can be constructed in several ways, and by using boards vertically or horizontally. A traditional method was to overlap one horizontal board with the one below it, and, on a sunny day, this arrangement casts shadows that break up an area of white. When boards are used vertically, they are butt-jointed and the joints are covered with a moulding strip.

When you are dealing with white-painted weatherboarding, you should try and set it against a dark background such as trees or bushes to emphasize contrast. Alternatively, you could run a light wash or use a pencil to darken any sky.

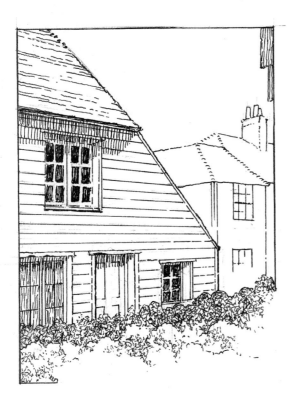

Above and above right: These two sketches show white-painted weatherboarding used as cladding for houses in the south of England. At this scale it is sufficient to show the boards with a single fine line.

Brickwork with windows

These sketches and diagrams show different aspects of brickwork and some ways of indicating them using pen and pencil. The large top-left sketch shows a late seventeenth- or early eighteenth-century sash window set in a Flemish bonded wall. The brick arches of windows in small houses were supported on slightly curved pieces of timber which formed part of the window frames. Later in the eighteenth century, some bricks were made from suitable red clays and these could be rubbed to shapes for making flat arches with very fine joints. The shapes of the rubbed bricks made it possible for them to make a flat arch without the bricks slipping. This type of brick was used in more important houses.

The three sketches of windows show the amount of detail you might include in the windows themselves and in the surrounding brickwork at different distances. When drawing the brickwork, just select small areas to show its detail. In the bottom-right window, I have chosen to show the effect of evening light, the outside wall and the window frame being in shadow while the glow from artificial light inside shines out.

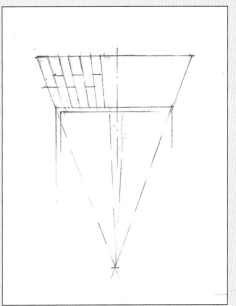

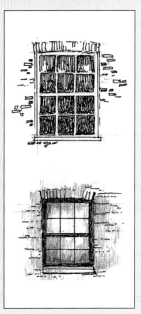

English bond

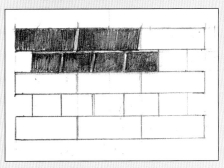

Flemish bond

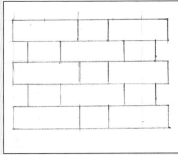

Stretcher bond

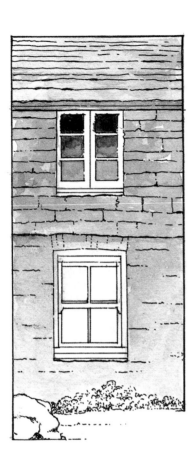

Slate roof
slurried
over

Slate-hung
wall

Casement
window

Victorian
sash window

Slate-stone
wall, colour
washed

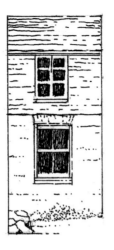

This page: Different types of windows shown in various types of walling and at different distances. In the top-left sketch the interest of the wall lies in the irregular textures of the slate-hung wall and its slate-stone surfaces. In the other (bottom-left) drawing, the interest lies in the pattern made by the arrangement of its accurately dressed stones. Versions simplified by distance are shown above.

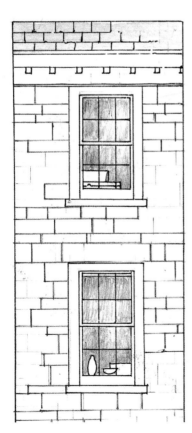

Wooden
cornice

Dressed
stone wall

18th-century
sash window

Windows Casement and sash windows are the traditional types found in old buildings, and these can vary widely in design and size. This page shows a few examples of house and cottage styles set in different types of walling. I have drawn these with the detail you might use if they are close to you and form an important part of your picture, and I have also shown how you might draw them if they are some distance away.

One of the main things to notice about windows is their position in a wall relative to the amount of sky reflected in them. Usually, the higher they are situated in a house or cottage in an open situation, the lighter the panes of glass will appear, and they will be lighter in tones than those on the ground floor. (I say an 'open situation', because the presence of trees or other buildings will cast shadows and reflections that could alter this appearance.) Old casement windows, with their panes of glass separated by lead strips (called 'cames'), will reflect glancing light

Sketching window panes

If you are drawing your window at a size that shows panes of glass in detail, you might feel that filling these with a lot of black ink would overpower the rest of your composition. Where this becomes a problem, you could indicate dark areas with thin vertical lines set close together, or you might like to colour them with a grey wash or coloured pencil.

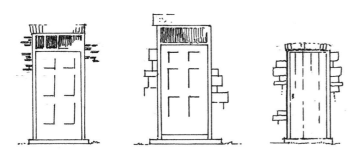

Above and below: These different types of doors are shown in various types of walls and at different distances. The door on the right is a simple boarded door found in small houses and cottages in rural areas. The one on the left is a typical Georgian door with raised panels and the one in the centre is from Victorian times and has sunken panels. The three sketches above show the same doors in their surroundings, with details simplified by the distance.

because each small pane is subject to some movement. If your drawn image is a size that will not show much detail, do not attempt to draw the actual thickness of wooden glazing bars. The depth at which windows are set in a wall will affect the amount of shadow cast by the sun and, naturally, this will alter as the sun moves around. The frame from the upper part of a sash window will cast a tiny shadow on the lower sash frame.

Doors Doors can be boarded or panelled. Old boarded doors were usually made from oak or elm, which was left in its natural state or given a coat of oil so the grain of the wood is visible. From the early nineteenth century, some boarded doors in country districts were made from imported wood, which needed painting.

The panelled doors of Georgian times (1714–1830) were painted, and the panels had bevelled edges and were slightly raised. The bevelled edges were in shadow away from the direction of light. The panels in Victorian (1837–1901) doors were recessed and received shadows cast by the door framing.

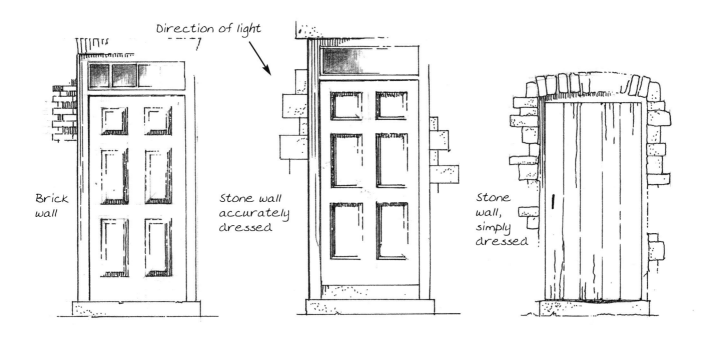

Direction of light

Brick wall

Stone wall accurately dressed

Stone wall, simply dressed

Ornament Ornament on buildings is everywhere and has been for thousands of years in different countries. It can be applied ornament carried out with paint, carved or sculpted in wood or stone, or engraved on glass. Whatever the process, the subjects reflect people's ways of life and their thoughts and aspirations.

When we admire these works from other artists, we want to interpret them by sketching our impressions, hoping to capture something of their beauty and meaning. So, with pens and pencils in hand, where do we start? These materials are particularly suitable for interpreting wood and stone carvings and sculptures. The soft ranges of pencils capture the gentle patina of wood, while pens, including brush-tips and fibre-tips, are suitable for stonework, along with pencil too.

One type of ornamentation you may encounter is decorative external plasterwork known as 'pargetting' (a term also used to describe a cement lining to a chimney flue). With this style of work, the design can either be incised or moulded in relief. Incised work was carried out by local craftsmen using simple wooden tools, and then applied to wet lime plaster. From this simple and very attractive work the craft developed from the mid- to late-nineteenth century (in England) into ornate relief work.

Other applied finishes include external plasterwork and pebble dashing ('harling' in some regions). Plasterwork can be plain, textured or very ornamental, and can be tooled simply or extravagantly moulded. Depending on the size of your drawing, you can show these with light lines or shadows. Stippling (i.e. fine dots placed at random) can be used to indicate plain plaster and pebble dashing.

Above: This ink sketch shows plasterwork with a relief moulding that was added to a fifteenth-century house during the seventeenth century. I have used thin lines to draw the pattern; at this scale, the shadows cast by the moulding would have be confusing in such an intricate design.

Emphasizing patterns
Sometimes materials themselves have patterns within them: the grain of timber, the particles that make up stone and the cavities in old bricks. These can be developed to make decorative illustrations with a strong emphasis on qualities of design.

Left: In this sketch of a wooden bench-end in a church I have used the side of an HB pencil to give graded tones – a soft treatment that emphasizes the shine on polished wood. I have also lightly picked out the grain of the timber, the appearance of which has been enhanced by years of polishing.

Right: This wooden bracket is from a late seventeenth-century half-timbered house which has herringbone-style brick panels. I have drawn the lines firmly, so as to show the definite lines of splitting down the grain of the old wood, which is probably oak. This bracket was made away from the site and fixed during the construction of the house; the wood grain of the bracket runs in a slightly different direction to the timbers.

Direction of light

Left: I have made this sketch of plasterwork in pencil, the incised pattern being shown by the shadow lines cast by the light coming from the top left. This circular pattern has been made by a wooden tool. and the pattern is indicated here by showing parts of the shadow. (If you wish you could lightly sketch some guidelines when you begin.)

Plants

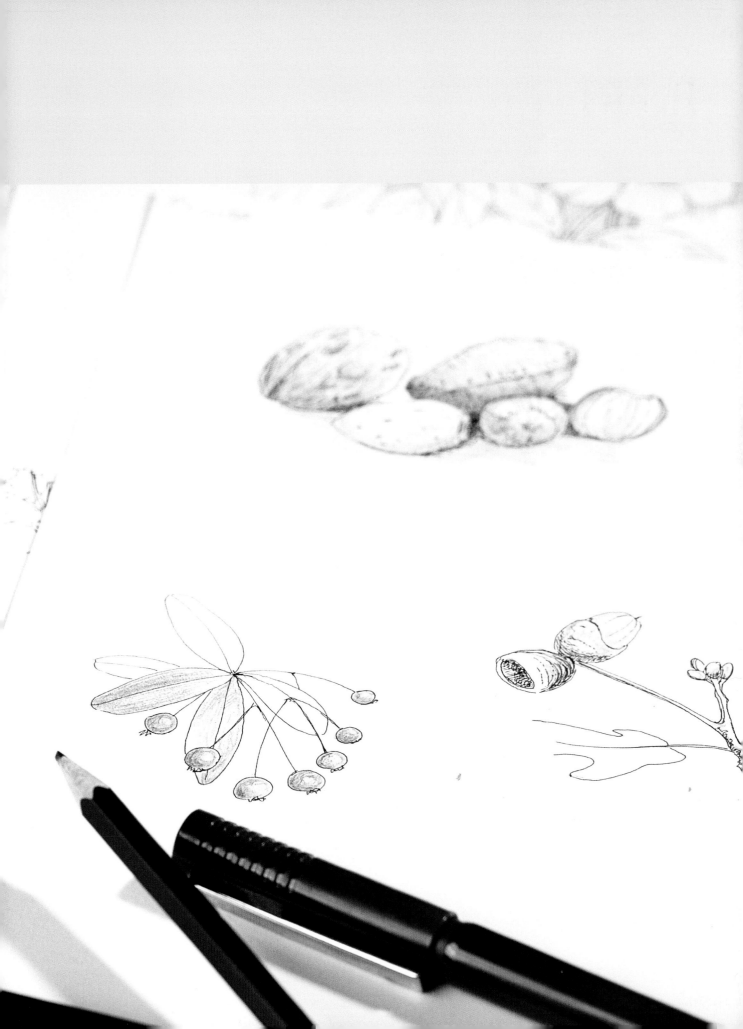

10 Plants

Wild plants in their natural surroundings can give atmosphere for making a sketch, while the more considered arrangements of plants in gardens and parks can give you opportunities for studying details of form, pattern and texture. These qualities are most suitable for expressing in a sketch made by using black or brown ink, or by using different grades of pencils.

English yew *Taxus baccata*
40ft (12m) at 70 years

What are known as wild plants in one part of the world are often cultivated in another. In order to protect our environment, please do not remove wild plants; sketch or photograph them in their places. Take a magnifying glass to see any details in them. If you understand the conditions in which plants thrive, you will find it easier to find them in wild places, gardens and parks.

Trees

The shapes and forms of trees make an important contribution to our surroundings. Distant woodlands and clumps can show different outlines according to whether they

Scots pine *Pinus sylvestris*
70ft (21m) at 65 years

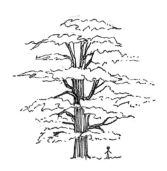

Cedar of Lebanon *Cedrus Lebani*
70ft (21m) at 60 years

Right: Trees are living things and their shapes and sizes vary with age. These sketches show some trees, with their generally known classifications and an indication of their shapes and heights at various ages. These should help you to look carefully at all trees and draw them in a way that will make your sketches more interesting and accurate.

I have sketched an adult person standing by each tree to give some indication of its size as drawn. Shapes will be simplified as the tree recedes into the distance, but its outline can still show some of its characteristics.

English elm *Ulmus procera*
65–70ft (20–21m) at 80 years

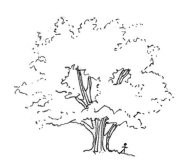

English oak *Quercus pendunculata*
55ft (17m) at 80 years

Yew *Taxus baccata*. **The size of this tree shows its clearly defined, soft-edged vertical fissures.**

16in
404mm

Scots pine *Pinus sylvestris*. **The size of this tree indicates its age and shows the shallow dividing scale-like plates.**

11in
280mm

Silver birch *Betula pendula*. **In a tree of this size the bark is fairly smooth and white with dark grey scaly patches.**

8in
202mm

This page: If you have a tree-trunk in the foreground of your picture, any patterns on the bark can give an additional interest. These sketches show patterns of bark, close to and at a distance.

I have used an HB pencil for the shading that shows the roundness of the tree-trunks. In this way it does not become confused with the bark pattern, which is shown in pen.

are composed of coniferous or deciduous trees, or viewed at different seasons. Single trees viewed in the middle distance show their shapes quite clearly, while a nearby tree can also show the construction of its branches, again in accordance with the different seasons. The age of a tree makes a difference to its size and shape. You do not need to draw every branch, just enough of the main ones to record how they help in making the overall shape.

The linear qualities of tree bark make it a particularly suitable subject for sketching in pen or pencil. The shapes and textures of leaves also make them good subjects; newly fallen leaves are usually readily available to study and draw. Details of tree bark and leaves are interesting to sketch because they can develop your abilities in drawing and recording. They will also add to your understanding of the whole tree itself.

The impact of shrubs and bushes will be seen mainly in the foreground of your picture, so their outline will be determined by the shapes of twigs, leaves and flowers.

Fruit and flowers

The fruits of trees, shrubs and bushes vary a great deal, from those showing mainly ornamental qualities, to those chosen for their medicinal and culinary values. Colour can play an important part in the appearance of some fruits, and other materials such as watercolour, oil and pastel will be chosen to give full strength to this impact of colour. However, some colour added to a very simple pen or pencil sketch can give an attractive interpretation of fruit. Nuts and pine and fir cones are also fruits, and the interest of these lies in their linear and textural qualities. Again, these are interesting to draw in pen or pencil.

This page: If you decide to keep a record of different trees, these drawings show the type of information you should include. I made these drawings away from the site a short time after my visit when I had made a rough sketch of this very old tree and had taken a photo. (You can judge its height relative to the adjacent cottages.) I also collected the cones and spray from those lying on the ground below it.

I made the drawing using waterproof ink with a fine mapping pen on HP paper. I just wanted a small drawing and a larger nib would have been too coarse to show the fine detail.

I next saw this tree four years later; the lower branches had nearly all fallen off and the tree was in its last years. It also showed some evidence of wind damage.

seeds

Must have a mild climate or sheltered position

Cupressus macrocarpa

Prefers thin calcareous soils or light sandy ones; cannot stand cold clay

Spray with cone

type of foilage arrangement

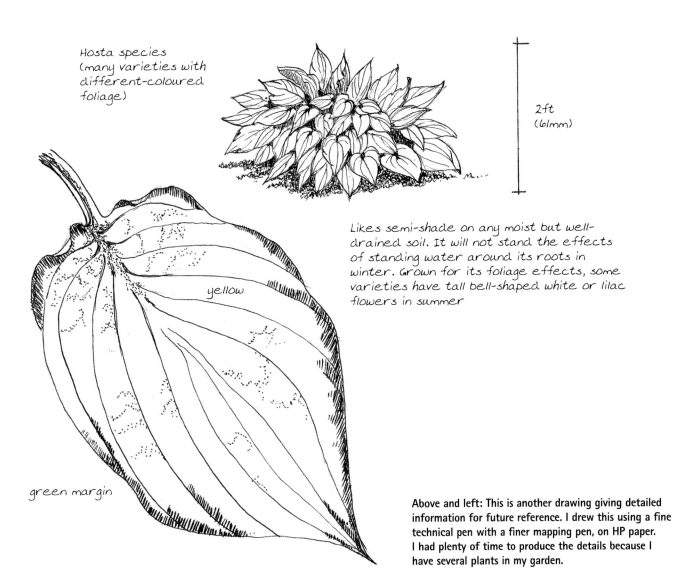

Hosta species (many varieties with different-coloured foliage)

2ft (61mm)

yellow

green margin

Likes semi-shade on any moist but well-drained soil. It will not stand the effects of standing water around its roots in winter. Grown for its foliage effects, some varieties have tall bell-shaped white or lilac flowers in summer

Above and left: This is another drawing giving detailed information for future reference. I drew this using a fine technical pen with a finer mapping pen, on HP paper. I had plenty of time to produce the details because I have several plants in my garden.

Left: Acorn from the English oak *Quercus robur*.

Right: Berries of pyracantha variety.

Left: I have drawn this white daisy flower in pencil to show how the softer gradations suit this particular subject. The leaves have a lighter tone than the background itself.

Right: This plant, *Cornus capitata*, has cream-coloured bracts (not petals), the number of which can vary, and it is grown as an ornamental tree in mild, sheltered districts. I have seen some specimens 30ft (9m) tall in the southwest of England.

I have drawn this in ink against a darker background in pencil. I chose to do this so that the ink lines of the plant stand out, but you could use a dark grey watercolour wash. I felt that solid black would be too forceful in this case.

Below: Edible domestic nuts.

Plants and colour

Where colour is the main attraction of some flowers, this quality can best be shown by the use of coloured pencils or by watercolour washes. Line work in pen needs to be very fine and kept to a minimum because any very definite marks will detract from the colour impact of the flower. However, white flowers drawn delicately against darker foliage and backgrounds can make attractive sketches.

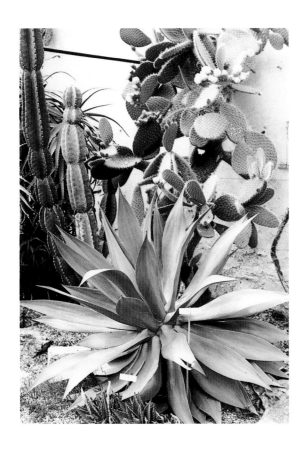

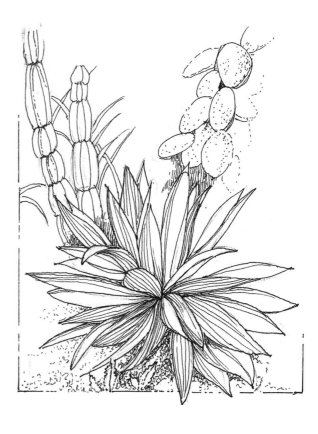

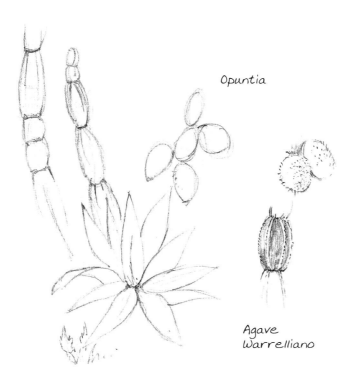

Opuntia

Agave
Warrelliano

Aloe Salmay kian

This page: I was attracted by the different shapes and textures of this group of plants in a glasshouse in a small public botanical garden. A heated glasshouse is not a good place to make a detailed sketch so I took a photo and made notes of the species for future reference with a little drawn detail.

When I arrived home I could see that there were different ways in which the group could be interpreted in a drawing, and I chose to emphasize line, shape and texture using pen and ink on HP paper (see page 36).

Water, earth and sky

11

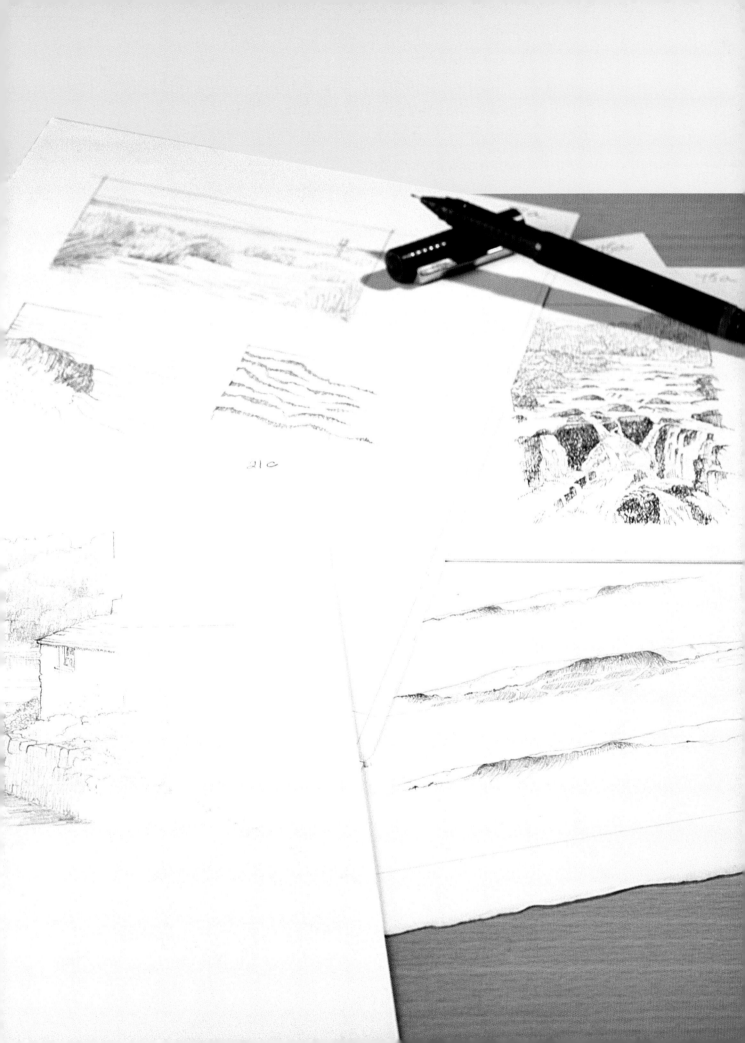

 # Water, earth and sky

The presence of water raises different responses in us depending on where we live and on what the weather conditions are. In dry areas of the world it is a life-giving source, but in areas that are subjected to flooding it can be terrifying and dangerous.

As artists, if we are pursuing a leisure activity, we can choose the time and season to look at our subject. Water, especially rapidly moving water, does need a period of observation before we even put pen or pencil to paper.

Using a camera to record water

A camera can be useful to record the different movements of the water and provide a record for future use. If your camera has adjustable shutter speed, you can speed it up to capture spray in detail, or slow it down to blur the image and give an illusion of movement.

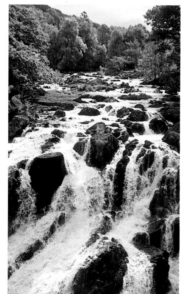

I took this photo from an easily accessible viewpoint near a car park. The purpose of the ink drawing, which I made later, is to show a dramatic part of the falls and the contrast between light foam and dark rocks.

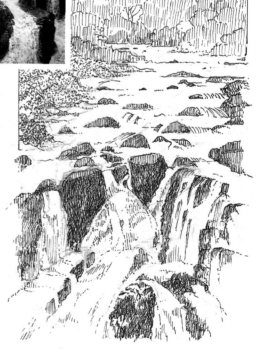

When you are drawing, it is important to pay particular attention to the direction of your pen or pencil strokes. Pencil can be particularly suitable for depicting some movements of water because its subtlety means your strokes can be softly graded. This is especially noticeable if you use a soft lead, such as a 3B or 4B, sharpened to a chisel point. You can then vary the pressure as you are drawing. However, reflections in still water or foam patterns in the sea can make quite different areas where the use of the pen can be very expressive.

When the view in front of you includes distant stretches of water, do not try to add detail to this; it should be reserved for the foreground, such as reeds near the bank, streams running over rocks, or waves breaking on the shore.

Waterfalls

Turbulent water, such as that in a waterfall or the sea, creates a feeling of excitement. Waterfalls can occur with relatively shallow cascades or very high ones. These are different in character depending on the type of terrain. Your sketches need to show the lines of the force of the water. The flow will depend on the amount of obstruction which it encounters, caused by rocky outcrops or boulders or fallen branches. Masses of smooth water occur when the fall drops from a height before plunging to the river below.

Try to include something that will give scale to your waterfall; near and distant trees can be useful in this respect. Foliage on the sides

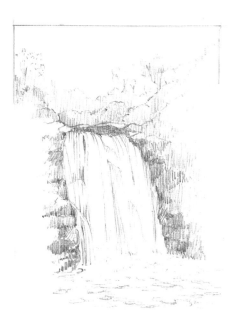

Above: This pencil drawing, also based on a photo taken from a safe viewpoint, shows a sheer sheet of water falling to the riverbed below with splashing foam. Pencil is good to use for this, giving softer gradations to the water and giving contrast by using different grades to show distances.

The photograph was taken using a camera fitted with a standard lens, not a wide-angle or telephoto lens that would distort the perspective. As a result, it is possible to assess the size of the fall as seen from a safe viewpoint.

The effects of weather conditions

Water can sparkle on a bright day, or be sombre in mist. Both atmospheres can result in the production of good pictures, although it is the quality of directional light on water that makes it most interesting to draw, because it emphasizes the slightest movement. Detailed studies, made when reflections are moving due to slight surface disturbance, can show the lovely resulting patterns.

Dealing with the spray

Sketching imposing waterfalls or the sea when you are close to them can make your paper damp. One way to cope with this situation is to make a few notes and take a photograph from which you can draw later on. Alternatively, you can use a transparent plastic bag that is large enough to take your sketchbook, in which you can also draw with one hand inside. (This is also a helpful trick if it starts to rain.)

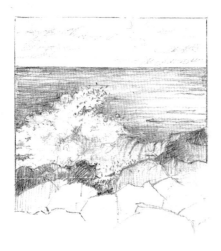

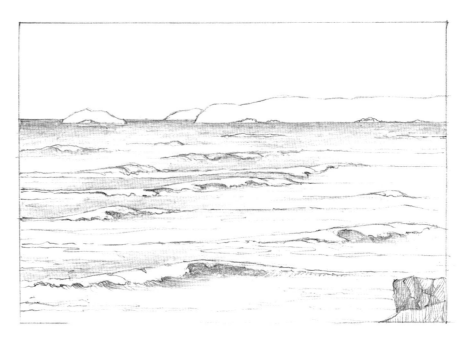

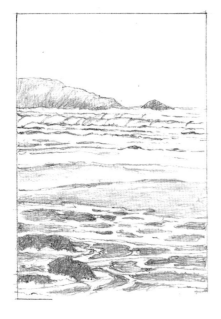

of a glen and boulders and rocks will be darker in tone than the foam of the water around and over them. It is important to avoid using too many tones; use the white of your paper for the foam.

High waterfalls, from their very nature, are usually situated in rocky glens traversed by narrow footpaths that are often slippery in the damp air and are not good places to sketch. If the fall of water is slight, perhaps when the river descends gently down slopes in more open situations, the water can sparkle in the sunlight, and the gentler ground is easier to sketch from.

The sea

While thrilling to observe, the sea in its most exciting moods, with high windswept waves and spray, is not very helpful in the making of close-up sketches. It is said that J.M.W. Turner (1775–1851) was lashed to the mast of a boat in order to observe a stormy sea off the south coast of England. This exploit is

This page: These three sketches have been made from notes and photos taken on holidays. The viewpoint for the largest sketch (top right) was a low cliff, giving a wide-ranging aspect, while the second, more immediate sketch (top left) shows spray rising behind nearby rocks on the edge of a different beach. The third sketch (above) was taken at the water's edge of yet another beach. It shows distant breakers, a sandbank over which the tide is gently lapping, and water swirling around the foreground rocks, leaving foam patterns in the sea.

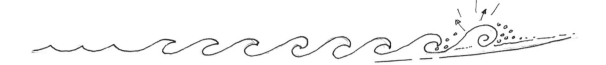

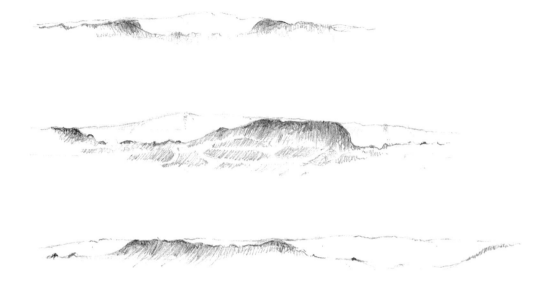

Left: The
development of a
wave from out at
sea to breaking on
the beach. I made
the three sketches
of changing wave
formations after
a few minutes of
careful observation.

not likely to be followed as a general rule, although I know of one artist who goes out in a small boat in various weathers to sketch the effects of the ever-changing weather conditions on his local coastline.

On a calm day, watch the rhythm of the breaker waves as they ride in and fold over to crash on to the beach. Watch how and where the light shines through, and where the darkest areas are. If the light stays constant, you will find that these patterns generally repeat themselves. In the area of the beach where the wave starts to recede, foam patterns are quite interesting. They are originally circular and form ellipses as they recede.

The main difficulty that you will encounter is that the impact of the sea relies on the contrast between white foam and the general background. The artist painting in colour can provide this easily by leaving flecks of white paper, or by using masking fluid or opaque white paint in dots to show spray. If you use pencil to depict waves, a light touch on the side of the lead can give a smooth, varying tone to contrast with breakers and foam. You will find it helpful to concentrate on the shapes and perspective of the waves with just a little shading to give the contrast.

Earth

The soft earth that we see around us is derived from the underlying geological formations, combined with the effects of climate, the action of water (especially that of rainfall), and sometimes the presence of decaying vegetable matter.

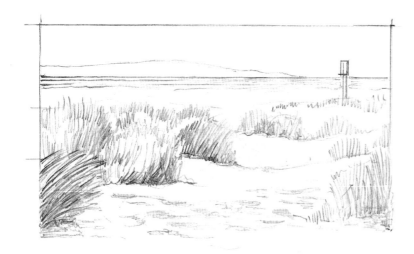

I made these sketches to show the different appearances of sand in various situations.

Left: This is a general view of a beach with low dunes, stabilized by grasses. The sand is dry and the surface softly undulating.

Middle: This is where the sand has been left in ridges by the receding tide and is very firm. (At a different scale you could imagine that the ridges were cliffs.)

Bottom: This sketch shows, diagrammatically, the ridge lines, which would be soft, made by the tide at the edge of the sea and around rocks where the water is spraying up.

The basic geology, together with these other influences, makes the different types of earth vary in colour. You might need to consider this fact if you are travelling somewhere new to sketch and are planning to add some colour to your work. Also, different colours will have different tonal values, which will be important in any monochrome study.

Countryside can be flat, undulating or rugged in form, and a number of areas will be altered in appearance by land management. The form of the land and the quality of the soil make the actual surface patterns. In some rural areas, these include linear patterns made by the plough, and some will have an overall patchwork design made by fields divided by hedges, fences or walls. Other forms of land use can give rise to linear patterns made by the construction of dykes and ditches in schemes of land reclamation and the rows and blocks of plant nurseries and orchards.

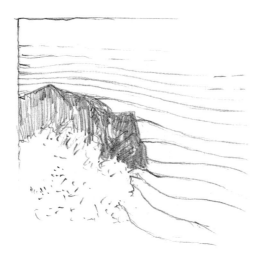

The artist can indicate the actual textures of the different surface soils in the foreground of pictures. You will see the smoothness of

moist, bare clay and how it splits into hard, polygonal shapes under drought conditions. Alternatively, peat can be cut into blocks and stacked for use as fuel in some remote rural districts, and the texture of sand is granular when it is blown by the wind to form dunes or ridged when the tide gently recedes.

I hope that by looking at the rural areas, you will see that the surface patterns and textures, either those evolving naturally or created by land management, can add to the interest of your pictures.

Sky

At certain times of the year, in certain countries, cloudless blue skies are a normal occurrence. In a picture, this can help to create a useful contrast with more detailed features in the land or sea below. The artist working in pen or pencil can choose to make this type of sky a minor part of the picture, adding only an indication of tone or leaving it as plain paper.

At other times, the sky can feature clouds, and these can evoke different moods according to the type of weather conditions. They can make an interesting part of a picture, or, if too complex, may detract from its other interests.

Cloud formations are often fast moving, always ephemeral, and can be hard to capture in a sketch. Due to their soft character, clouds are particularly hard subjects to draw by pen, unless the ink is water soluble, in which case washes can be introduced. On the other hand, pencil is well suited to creating the softly shaded light and dark areas of a cloudy sky.

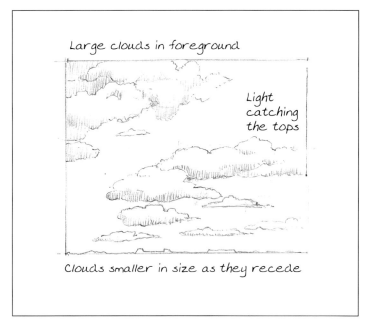

Large clouds in foreground

Light catching the tops

Clouds smaller in size as they recede

You can make these by close cross-hatching layer on layer with even pressure, adding more layers in darker areas. And it should also be noted that clouds need to be drawn with due regard to both aerial and linear perspective (as shown in the sketch above).

A camera can be useful here, especially as it can be used a number of times to build up a collection of cloud formations so that you can study them for use later in your pictures. You need to be careful to match the clouds above with the land or sea below, and with the weather conditions that were present at the time when you made your sketch.

From a study of cloud formations gained from various sources, together with their names, you can make a written note – for example, cirrus, cumulus, and so on – at the time of sketching and add the drawing of these later.

Still life

12 Still life

Still life is usually associated with groups of flowers, fruit, vegetables and simple domestic objects beautifully depicted in some of the paintings of both past and present-day artists.

The idea of making a still-life drawing might be appealing to you if you have some interesting articles that mean a lot to you, perhaps bringing back memories of holidays, days out or festive occasions. Alternatively, you might have old pictures or treasured objects that you have collected over the years.

Selecting appropriate subjects

Because you will be drawing in pen or pencil, you will need to choose items that have predominantly textural, linear or reflective qualities. Some of these objects might also lend themselves to the addition of a light wash or a little colour, but you need to be careful that this does not overwhelm the rest of your picture.

You can arrange your still life wherever you choose, but because some of your objects might lend themselves to being drawn in detail, it will probably be more convenient if you set them up in indoors, where you can control the environment. This should be in a place where they can remain undisturbed for some time and where you can select the most appropriate lighting.

Still life can also include details of buildings and garden features. If you are outdoors with your sketchbook, you could find these and other small objects interesting, and they can be drawn in a relatively short period of time. Objects might include pebbles of interesting shapes or with unusual patterns, shells, pieces of driftwood, tree branches, flowerpots, rusty watering cans or other metal objects with flaking paint, boxes and anything with a linear or textural quality.

Lighting still-life subjects

For any type of still-life sketch, indoors or out, lighting is particularly important. Soft, directional lighting is the most helpful. If the lighting is too harsh, deep shadows will dominate to the extent that they will overpower other aspects of what should be an interpretation of small, intimate items. If the lighting is too flat, any textural qualities will lack emphasis.

Vignetting (see page 46) can be attractive technique to employ when drawing a still life. Fading the edges of it into blank paper can help to minimize the effect of any distracting background.

1in (25mm)

1¼ in (35mm)

Shell and
very smooth
black-and-
white pebble

2in (50mm)

1¾ in (45mm)

2in (50mm)

Grey pebble, grainy
surface rounded by wave
actions

1½ in (40mm)

Irregularly shaped pebble,
drawn for its patterns
and colours

Side view

Still life 135

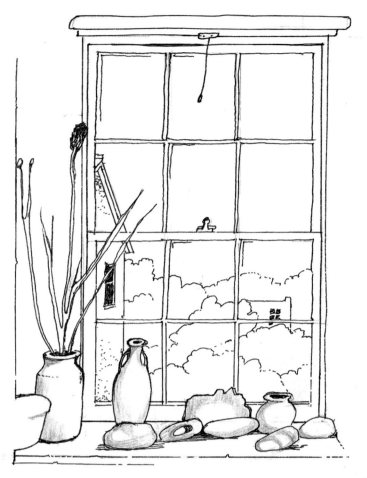

Below: I liked the colours and shapes of the flowers and leaves in two of these plants, but I didn't want to make a large sketch of them on their own. I decided to draw the whole window and the landscsape beyond and add colour to the plants which that first attracted me. This approach shows them in their surroundings, which makes the picture interesting and emphasizes their particular appeal to me.

Above: If you do not wish to set up a large still-life group, think about placing some items on a windowsill with the view through the window as a background. You will need to watch lighting carefully because your items will receive some back-light through the window. I sketched this scene in a friend's studio where she had placed a selection of pebbles and pottery on the windowsill.

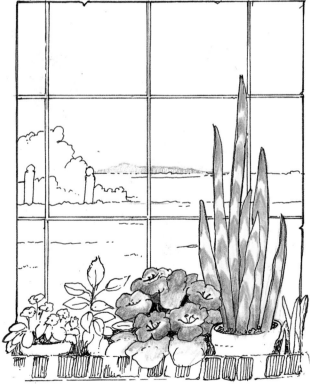

Carved stone band on a house

This page: Try to draw stone carving when the light casts shadows to show the detail of it. If your image is small, try drawing the shadows only: do not outline the design. If your drawing is larger you could indicate texture but still use the shadows to create the form.

about 10in (250mm)

Stone carving at the edge of an arch over a doorway in a small church. Walls built of flint (some split) with stone dressings

About the author

Joyce Percival is the author of *Architecture for Dolls' Houses* (ISBN 0 946819 98 X), which she illustrated herself. She was elected a Fellow of the Royal Society of Arts in 1975. A qualified architect since 1950, Joyce has displayed a keen interest in working to improve the environment. To this end, she has worked with a number of illustrious bodies, including the Historic Buildings section of Greater London Council, the Civic Trust, and the Department of the Environment. Other than drawing and painting, her hobbies include dolls' houses, photography and embroidery.

Useful sources

The Artist's Drawing Book Moira Huntly (David and Charles, 1994)
Drawing and Painting Buildings Ray Evans (Collins, 1983)
Drawing Problems and Solutions Trudy Friend (David and Charles, 2001)
Pen and Wash (Video) Margaret Evans (Teaching Art Ltd, 2002)

Index

GMC Publications

BOOKS

WOODCARVING

Beginning Woodcarving	GMC Publications
Carving Architectural Detail in Wood: The Classical Tradition	Frederick Wilbur
Carving Birds & Beasts	GMC Publications
Carving the Human Figure: Studies in Wood and Stone	Dick Onians
Carving Nature: Wildlife Studies in Wood	Frank Fox-Wilson
Celtic Carved Lovespoons: 30 Patterns	Sharon Littley & Clive Griffin
Decorative Woodcarving (New Edition)	Jeremy Williams
Elements of Woodcarving	Chris Pye
Figure Carving in Wood: Human and Animal Forms	Sara Wilkinson
Lettercarving in Wood: A Practical Course	Chris Pye
Relief Carving in Wood: A Practical Introduction	Chris Pye
Woodcarving for Beginners	GMC Publications
Woodcarving Made Easy	Cynthia Rogers
Woodcarving Tools, Materials & Equipment (New Edition in 2 vols.)	Chris Pye

WOODTURNING

Bowl Turning Techniques Masterclass	Tony Boase
Chris Child's Projects for Woodturners	Chris Child
Decorating Turned Wood: The Maker's Eye	Liz & Michael O'Donnell
Green Woodwork	Mike Abbott
Keith Rowley's Woodturning Projects	Keith Rowley
Making Screw Threads in Wood	Fred Holder
Segmented Turning: A Complete Guide	Ron Hampton
Turned Boxes: 50 Designs	Chris Stott
Turning Green Wood	Michael O'Donnell
Turning Pens and Pencils	Kip Christensen & Rex Burningham
Woodturning: Forms and Materials	John Hunnex
Woodturning: A Foundation Course (New Edition)	Keith Rowley
Woodturning: A Fresh Approach	Robert Chapman
Woodturning: An Individual Approach	Dave Regester
Woodturning: A Source Book of Shapes	John Hunnex
Woodturning Masterclass	Tony Boase

WOODWORKING

Beginning Picture Marquetry	Lawrence Threadgold
Celtic Carved Lovespoons: 30 Patterns	Sharon Littley & Clive Griffin
Celtic Woodcraft	Glenda Bennett
Complete Woodfinishing (Revised Edition)	Ian Hosker
David Charlesworth's Furniture-Making Techniques	David Charlesworth
David Charlesworth's Furniture-Making Techniques – Volume 2	David Charlesworth
Furniture Projects with the Router	Kevin Ley
Furniture Restoration (Practical Crafts)	Kevin Jan Bonner
Furniture Restoration: A Professional at Work	John Lloyd
Green Woodwork	Mike Abbott
Intarsia: 30 Patterns for the Scrollsaw	John Everett

Making Heirloom Boxes	Peter Lloyd
Making Screw Threads in Wood	Fred Holder
Making Woodwork Aids and Devices	Robert Wearing
Mastering the Router	Ron Fox
Pine Furniture Projects for the Home	Dave Mackenzie
Router Magic: Jigs, Fixtures and Tricks to Unleash your Router's Full Potential	Bill Hylton
Router Projects for the Home	GMC Publications
Router Tips & Techniques	Robert Wearing
Routing: A Workshop Handbook	Anthony Bailey
Routing for Beginners	Anthony Bailey
Stickmaking: A Complete Course	Andrew Jones & Clive George
Stickmaking Handbook	Andrew Jones & Clive George
Storage Projects for the Router	GMC Publications
Veneering: A Complete Course	Ian Hosker
Veneering Handbook	Ian Hosker
Woodworking Techniques and Projects	Anthony Bailey
Woodworking with the Router: Professional Router Techniques any Woodworker can Use	Bill Hylton & Fred Matlack

UPHOLSTERY

Upholstery: A Complete Course (Revised Edition)	David James
Upholstery Restoration	David James
Upholstery Techniques & Projects	David James
Upholstery Tips and Hints	David James

DOLLS' HOUSES AND MINIATURES

1/12 Scale Character Figures for the Dolls' House	James Carrington
Americana in 1/12 Scale: 50 Authentic Projects	Joanne Ogreenc & Mary Lou Santovec
The Authentic Georgian Dolls' House	Brian Long
A Beginners' Guide to the Dolls' House Hobby	Jean Nisbett
Celtic, Medieval and Tudor Wall Hangings in 1/12 Scale Needlepoint	Sandra Whitehead
Creating Decorative Fabrics: Projects in 1/12 Scale	Janet Storey
Dolls' House Accessories, Fixtures and Fittings	Andrea Barham
Dolls' House Furniture: Easy-to-Make Projects in 1/12 Scale	Freida Gray
Dolls' House Makeovers	Jean Nisbett
Dolls' House Window Treatments	Eve Harwood
Edwardian-Style Hand-Knitted Fashion for 1/12 Scale Dolls	Yvonne Wakefield
How to Make Your Dolls' House Special: Fresh Ideas for Decorating	Beryl Armstrong
Making 1/12 Scale Wicker Furniture for the Dolls' House	Sheila Smith
Making Miniature Chinese Rugs and Carpets	Carol Phillipson
Making Miniature Food and Market Stalls	Angie Scarr
Making Miniature Gardens	Freida Gray

CRAFTS

GARDENING

Success with Seeds	Chris & Valerie Wheeler
Tropical Garden Style with Hardy Plants	Alan Hemsley
Water Garden Projects: From Groundwork to Planting	
	Roger Sweetinburgh

PHOTOGRAPHY

Close-Up on Insects	Robert Thompson
Digital Enhancement for Landscape Photographers	
	Arjan Hoogendam & Herb Parkin
Double Vision	Chris Weston & Nigel Hicks
An Essential Guide to Bird Photography	Steve Young
Field Guide to Bird Photography	Steve Young
Field Guide to Landscape Photography	Peter Watson
How to Photograph Pets	Nick Ridley
In my Mind's Eye: Seeing in Black and White	Charlie Waite
Life in the Wild: A Photographer's Year	Andy Rouse
Light in the Landscape: A Photographer's Year	Peter Watson
Photographers on Location with Charlie Waite	Charlie Waite
Photography for the Naturalist	Mark Lucock
Photojournalism: An Essential Guide	David Herrod
Professional Landscape and Environmental Photography:	
From 35mm to Large Format	Mark Lucock
Rangefinder	Roger Hicks & Frances Schultz
Underwater Photography	Paul Kay
Where and How to Photograph Wildlife	Peter Evans
Wildlife Photography Workshops	Steve & Ann Toon

ART TECHNIQUES

Oil Paintings from your Garden: A Guide for Beginners	Rachel Shirley

VIDEOS

Drop-in and Pinstuffed Seats	David James
Stuffover Upholstery	David James
Elliptical Turning	David Springett
Woodturning Wizardry	David Springett
Turning Between Centres: The Basics	Dennis White
Turning Bowls	Dennis White
Boxes, Goblets and Screw Threads	Dennis White
Novelties and Projects	Dennis White
Classic Profiles	Dennis White
Twists and Advanced Turning	Dennis White
Sharpening the Professional Way	Jim Kingshott
Sharpening Turning & Carving Tools	Jim Kingshott
Bowl Turning	John Jordan
Hollow Turning	John Jordan
Woodturning: A Foundation Course	Keith Rowley
Carving a Figure: The Female Form	Ray Gonzalez
The Router: A Beginner's Guide	Alan Goodsell
The Scroll Saw: A Beginner's Guide	John Burke

MAGAZINES

◆ WOODTURNING
◆ WOODCARVING
◆ FURNITURE & CABINETMAKING
◆ THE ROUTER
◆ NEW WOODWORKING
◆ THE DOLLS' HOUSE MAGAZINE
◆ OUTDOOR PHOTOGRAPHY
◆ BLACK & WHITE PHOTOGRAPHY
◆ MACHINE KNITTING NEWS
◆ KNITTING
◆ GUILD OF MASTER CRAFTSMEN NEWS

The above represents a full list of all titles currently published or scheduled to be published.

All are available direct from the Publishers or through bookshops, newsagents and specialist retailers.

To place an order, or to obtain a complete catalogue, contact:

GMC Publications,
Castle Place, 166 High Street, Lewes, East
Sussex BN7 1XU United Kingdom
Tel: 01273 488005 Fax: 01273 402866
Website: www.gmcbooks.com
E-mail: pubs@thegmcgroup.com

Orders by credit card are accepted